CW01301177

# SPIRIT

Text and photography: Dan Pearson

Additional photography: Huw Morgan

Editorial:
Dan Pearson, Huw Morgan, Anna Benn,
Damon Murray, Stephen Sorrell

Design: Murray & Sorrell FUEL

First published in 2009

Murray & Sorrell FUEL ©
Design & Publishing
33 Fournier Street
London E1 6QE

www.fuel-design.com

All rights reserved.
No part of this publication may be reproduced without the
written permission of the publisher or the copyright owner.

The right of Dan Pearson to be indentified as the Author
of the Work has been asserted by him in accordance with
the Copyright, Designs and Patents Act 1988.
© Dan Pearson 2009

Scans by Happy Retouching
Printed in Hong Kong

Distributed by Thames & Hudson / D.A.P.
ISBN 978-0-9558620-8-3

# SPIRIT

DAN PEARSON

GARDEN INSPIRATION

FUEL

| | |
|---:|---|
| 7 | FOREWORD |
| 8 | PREFACE |
| 12 | BEGINNINGS |
| 22 | PAINSHILL PARK |
| 24 | JERUSALEM |
| 28 | A GOWER WALK |
| 38 | MANAGED LANDSCAPE |
| 42 | ROUSHAM |
| 52 | CHELSEA PHYSIC GARDEN |
| 54 | TREES |
| 62 | JAPAN |
| 68 | ISAMU NOGUCHI |
| 70 | HENRY MOORE 'LARGE TWO FORMS' |
| 72 | ANISH KAPOOR 'MARSYAS' |
| 74 | YOSEMITE |
| 80 | CHICAGO PRAIRIES |
| 86 | ANISH KAPOOR 'CLOUD GATE' |
| 88 | COMMUNITY GARDENING |
| 102 | JAPANESE GARDENS |
| 108 | HOKKAIDO FOREST HOUSE |
| 114 | EDWINA'S RETREAT |
| 118 | JP'S CABIN |
| 120 | CHERRY WOOD PROJECT |
| 124 | WISTMAN'S WOOD |
| 130 | NEW ZEALAND |
| 140 | PANTHEON |
| 144 | JAMES TURRELL 'DEER SHELTER' |
| 148 | RICHARD SERRA 'SIDEWINDER' |
| 150 | MEMORIAL |
| 156 | LE PALAIS IDÉAL |
| 158 | NOTRE DAME DU HAUT |
| 160 | JOSHUA TREE NATIONAL PARK |
| 164 | HUNTINGTON BOTANICAL GARDENS |
| 168 | LOTUSLAND |
| 172 | KIRSTENBOSCH NATIONAL BOTANICAL GARDEN |
| 176 | CABO DE GATA |
| 186 | ALHAMBRA |
| 190 | WATER |
| 194 | VILLA D'ESTE |
| 198 | FONTANA DI TREVI |
| 202 | TORRECCHIA |

**FOREWORD**

In the opening pages of this extraordinary book you might wonder how such scenes could possibly influence garden design today planned among the glass and concrete jungles of modern living. Yet, through his passion for plant life in all shapes and forms together with his affinity with plants in their natural environment, Dan Pearson shows how the most intimidating situations can be transformed. It takes a rare mind and eye to break away from our traditional view of what makes a garden, but through his many and varied experiences worldwide, Dan's mind has been clearly focused on what truly matters; the relationship between man, the natural world, and his own environment.

Originally gardens were designed to protect people and plants from the alarming wilderness outside. Today the majority of people live in urbanised communities so far removed from the natural world that even the possibility of rainfall, this basic requirement of life, is usually referred to by the weatherman as a threat. As gardeners we regularly complain about the weather but have continued to plant our gardens in the same style as have the generations before us, using familiar and much-loved cultivars, not always considering that plants, like people, do not take kindly to being thrust into the nearest available space, (or job).

We are experiencing a new and disturbing phenomenon, global warming, which is affecting our accustomed weather patterns. We find it hard to change long-established thought and traditions, but in this book we see how Dan has drawn inspiration from observing natural plant communities growing in widely varying conditions, and shows how we can learn from them, to find plants adapted to seemingly impossible situations.

Both the original style of writing and amazing photographs take my breath away. Who else would think of writing this in a gardening book? 'A blinding, white-hot day will allow you to concentrate on the sound and weight of your footfall, the hiss of the wind in the tussocky grasses, the still as you descend into the hollows and the smell of rosemary and thyme'.

He goes on to show how man's hunger for spiritual comfort and peace is found in nurturing plants – on a balcony, houseboat, by curtaining bare walls with living greenery. Most heart-warming is the chapter on community gardens. I too have seen the extraordinarily vibrant gardens created from waste dumps in between towering, formidable skyscrapers in New York, and learned how they encouraged neighbours to climb down from their lonely towers to share the common joy of tending plants, whether edible, decorative or both.

Dan Pearson's philosophy of gardening, so sensitively portrayed in this deeply felt, personal book, provides hope and inspiration for all of us who welcome a visionary in these changing times.

Beth Chatto
May 2009

**PREFACE**

*Spirit* is a book that attempts to capture a series of moods and to explain why they matter. I have been trying for some time to encapsulate these observations in photographs, but photographs can only reveal so much of the subject matter, which by its very nature is elusive.

Through lecturing and giving the images flesh with words, I came upon the idea of trying to pin down the spirit of place in a book. It is a subject that has fascinated me since I was a child and today it underpins my work. In the book I hope to reveal a way of seeing and how I have learned to understand and ultimately feel what for me gives a place its identity and character.

Spirit of place derives as much from the way a place is thought about or used as it does from its physical aspects. It may be strongly enhanced by the place being written about or painted, put to music or indeed shaped by the hand of man giving it focus. It lies in the invisible weave of culture. The stories, the art, the memories, the beliefs, the histories, the monuments, the boundaries, the rivers, woods and architectural styles are all key to the way in which we relate to our surroundings.

As a garden and landscape designer I find this fascinating, this is where gardens play their part, for they allow us to access landscape and nature and to a degree feel part of it. I hope that the following pages will encourage something of value to bubble up to the surface for you, as it has done for me over the years, by simply taking the time to look.

PREFACE

# BEGINNINGS

I have been gardening since the age of five or six and cannot imagine life without it. I remember quite clearly the pond that my father dug out in the orchard that opened this world of alchemy. It was no more than a six foot square with turf folded over the edge of the plastic liner. I spent what must have been hours that summer, lying on the grassy edge with my eyes on the watery lens.

The plant order arrived in the post, a fetid collection of muddy bags containing water lilies and iris and a small clutch of waterweeds and marginals. A jar of primitive-looking snails was dropped into water that had greened within days of filling the depression. The oxygenating weed was tied to stones to keep it down and lowered to the bottom and the lilies sunk in their pots, the air bubbling up as the only indicator as to their position. The marginals were pushed into the warm mud at the side and within days the water miraculously cleared to reveal the snails making their way through a world that was already shifting to find its equilibrium. Tapering stems holding embryonic lilies craned towards the light until one day the first leaves broke the surface. Under the lily pads were gelatinous clusters of eggs laid already by the snails. The reeds and the water mint speared the surface to fray the pond into the long grass of the orchard and soon there were dragonflies dive-bombing and pond skaters with feet pushing indentations into the tension on the water. Each day brought something new. I was hooked.

Most people who garden have a gardening mentor, be it a close relative, a neighbour or a place that is indelible or influential. As a child I was lucky enough to have all of the above and to this day, am grateful for discovering my vocation so early. Of course, the people and the places were pivotal. My parents were relaxed gardeners but we always had plants around us and were encouraged to feel part of our environment. It was an outdoor life.

My mother had the vegetable patch. She was brought up in vicarage gardens and her father grew vegetables for the family, which she did in turn for us. Grandpa Bevan handed down the phrase 'and it was all from the garden' when sitting down to eat and we knew the importance of being able to appreciate food that was fresh and home-grown. My father grew the colour in the garden and he was brave and uninhibited with it. Although one of the best things about gardening is its solitary nature, they have always been there to listen and to encourage. A great part of the evolution is in the sharing.

I was also lucky to be just a few minutes away from my great friend Geraldine, who opened her doors to me when she found out that I had the bug. She must have been in her mid-sixties then and retired from teaching and I was welcome to make my way through the garage whenever I wanted. Geraldine was a passionate naturalist and her garden was full of life. Every plant had a story behind it and had to battle it out with the weeds. That said, she knew about plants, what they liked and with whom they liked to live. The nerine and Algerian iris thrived on the hot wall under the fig, the hepaticas and cyclamen formed carpets under a witch hazel and the bearded iris pushed through self-sown eschscholzia and scarlet pimpernel. She would part a tassel of grasses and tangled fumitory and invite me to look at the *Fritillaria pyrenaica*.

The fritillaria and other treasures, such as the ramondas that she grew in a thrown-together rockery, were smuggled back from her yearly trips to the mountains of Europe. She would arrive home tanned and interested to see how I had looked after the morning glory, the plumbago and tomatoes and then open the boot of her Morris Minor to unwrap muddy treasures from moistened newspaper. She would tell me about the alpine meadows and rock faces where these plants had grown and describe what she had seen them growing with. It was a rich education that combined the doing with the imagination.

Each and every day of the year, there would be a posy on the table pushed into a jam jar, a mug or a vase if that was what came to hand. In it, a moment from her garden would be distilled on the kitchen table and to this day I try to keep up the tradition, bringing plants up close so that their transformation from bud to death throe is fully understood. Having them near allows you to experience their perfume and colour combinations or associations you might never have recognised out in the garden.

Despite the age gap, we became the best of friends. We would team up to grow a trestle full of plants that were sold on a stand in the village and it was Geraldine who championed my yearly entries in the village Garden Show at the end of the summer holidays. Every year we would trundle down the hill, the car sloshing with exhibits that were destined for the display benches. Best roses, vegetables and vases of garden flowers, of which Geraldine's were always distinctively wild, would be pitted in competition with the local gardening fraternity.

Opposite Geraldine, there was a house called Hill Cottage. A vast, untamed laurel hedge leaned into the road and all you could see of the house was a chimney sprouting a solitary birch tree. Miss Joy, the owner, lived there with an army of rats, which as legend had it, had gnawed a hole under every door in the house. Every autumn she emerged from a break in the hedge to distribute windfalls on people's doorsteps. Tall, bent almost double with age, she donned a collection of faded home-made hats and I remember quite clearly being

13

frightened by her when she arrived to tip the basket's contents at the door, because you could never see her face. At that point I had no idea how influential Miss Joy's legacy would be.

One autumn in the mid 1970s Miss Joy failed to emerge from the hole in the hedge and a neighbour found her collapsed in the orchard after a stroke from which she never recovered. After she died, the house came up for sale. My mother, with her vicarage upbringing, has always been mad about old buildings, so she offered her services when our neighbour, the executor, went in to clear the house. Until then, I had never been as frightened and excited in the same moment and I shall never forget the weight and the tangle, the indelible gloom and the mood that lay behind the hedge.

The garden had completely overwhelmed the old lady and laurel and rhododendrons pressed against the windows to fill the house with an eerie submarine light. Ivy had nested in the gutters and *Akebia quinata* had made its way under the skirting boards. It wrapped itself around furniture that was shrouded in mouldering dustsheets. A perfect imprint of sawdust under a grand piano marked the woodworm activity and the damp had rotted the curtains halfway from the floor. Sure enough, the rat holes were under every door.

We pulled disintegrating fur coats from wardrobes, smelled the remains of her lavender water in pretty glass jars and opened chests to find them filled with string and brown paper. The kitchen was a labyrinth of newspapers piled waist high and swags of cobweb connected light shades and cornices. A cloud shape of mould covered the wall by Miss Joy's pillow – a mark of her breath in the chill of the unheated house. But my mother fell in love with Hill Cottage and, in a huge and reckless leap of faith, my parents bought it.

The garden extended to an acre and its gentle restoration became my world for the next seven years until I left home. It took the best part of three years to clear a way into it and there were bonfires every weekend. It was six months before we made our way to the far side of the house. This was the site of an old rose garden and a twisted *Rosa multiflora*, the rootstock of a long-overwhelmed rose that must once have been there, supported a rotting balcony. The garden had returned to woodland but, at the end of a little track to the orchard, where Miss Joy had made her way to stoke a small boiler, there was a shattered greenhouse containing a camellia that died that first winter. The lawn had been taken over by a pernicious thicket of bamboo and Japanese knotweed. One day we cut a tree to find a ruined pond, filled to the brim with fallen leaves and stinking. Another day a

BEGINNINGS

felled laurel opened up two long borders choked with ten-foot nettles and brambles. Underneath the thicket, crimson peonies and day lilies were blooming miraculously in the half-light.

An old picture revealed that Miss Joy had planted the vast Turkey oak in the centre of the garden. She had sown it from an acorn brought back from her years as a nurse in the First World War. It was just one of many treasures that remained from the garden's heyday. Twisted amelanchier strained for light amongst majestic Scots pines, and exotic rhododendrons teetered tall and unstable in feet of leaf mould. Gaunt apple trees in the orchard were a carpet of bluebells in the spring. As we cleared, plants that I had never heard of emerged from the undergrowth. One February day the wintersweet revealed itself in a thicket of bramble through scent alone, and the spring marbling of new epimedium foliage alerted us to a forgotten clump competing with the ground elder. Curious pink and grey-pink primroses, that must have crossed with polyanthus years beforehand, studded the mossy understorey and a solitary pure white trillium emerged amongst the suckering robinias to remind us of Miss Joy's passions as a gardener.

I learned an enormous amount about balance in this garden; that if you disturb what has become the equilibrium, nature will waste no time in compensating. We made a clearing in the saplings only to find that a spangled dell of speedwell, stellaria and primroses was lost to lurking ground elder and nettles in a season. I also learned about the appropriateness of things and that it is unwise to work against your conditions and far better to work with them. By then I had a Saturday gardening job for Mrs Pumphrey who opened her garden to the public. She was a very different gardener to Geraldine, self-taught, as many gardeners are, but intuitive in her approach to colour, form and texture. I would marvel at her plant combinations at Greatham Mill and trundle back up the hill on my bike laden with plants having spent every penny in her small nursery. Where her garden was hearty and muscular, with sun, moisture from a stream and a rich clay soil, our conditions were thin and fragile by comparison. Hungry to learn, I wanted what I didn't have, but try as I might to grow plants that loved the sun or a deep wet soil, there was just no point. The nature of the garden would not allow it and I learned the hard way that you had to work with nature and not against it if you were to succeed.

BEGINNINGS
17

My first plan for the yellow border, 1979.

My dad took me to the Chelsea Flower Show in 1976 and it was there that I first saw Beth Chatto's work. At that point, her stand was light years ahead of everyone else's. Her selections were wild plants, or the best selections of them, grouped in associations that were inspired by nature. Lush moisture lovers were grouped together, whilst the dry loving silver plants were woven amongst each other in associations that I would instantly understand when I went to the Mediterranean not so much later. Here was the best of Geraldine's naturalism, coupled with Mrs Pumphrey's eye for a good combination and in it a way forward that allowed me to make the most of the conditions in our woodland clearing.

At sixteen I toyed with the idea of going to art college, believing that I should break my obsession with gardening by widening my horizons but my parents encouraged me to 'do what you love doing most'. A two-year apprenticeship at Wisley was the best introduction to horticulture that I could have hoped for and I absorbed the experience and information like a fanatic. However, it was during a year at the Edinburgh

Botanic Garden that I had a major revelation. A small group of us won an award from the Alpine Garden Society to visit the Picos de Europa in Northern Spain and here I saw for the first time what Geraldine had been talking about. We drove across the Pyrenees to get there, the cool north-facing slopes alive with mourning widow and *Lilium pyrenaicum*. Astrantia and *Lilium martagon* illuminated hazel woods in a matchless combination and the free-draining limestone of the Picos showed me meadows more beautiful than any garden. Tiny medieval fields, so steep that they had to be hand scythed, revealed a managed landscape of tumbling vetches, moon daisy and electric-blue iris. Higher up, where it was too steep to work the land, sheets of dog's tooth violet hovered with hoop petticoat narcissus just below the snowline.

This trip prompted others and whilst I was studying at Kew, I visited the Valley of Flowers in the Himalayas. We climbed for days, ascending slowly through coniferous woods peppered with sinister arisaemas. Higher up, amongst the clouds in the valley itself, swathes of persicaria, potentilla and lady's slipper orchid rolled away in streaks of colour as far as you could see. They mapped the underground watercourses, or the drier seams of scree. It was a life-changing journey and it cemented my passion for understanding plants in their environment and the many constituents that actually make up a landscape. It also prompted the thought that I might be able to capture the appropriateness of things in their place if I learned to read what was around me. I knew I wanted to translate the freedom found in a natural landscape and work something of it into a garden setting.

I was lucky enough to be able to put some of these thoughts into action because I had already met my first client and long-term friend Frances Mossman. She had also fallen under Beth Chatto's spell and we went on to make three gardens together. The first, whilst I was at Wisley was a study in plant combinations. This was very much according to Beth's aesthetic; the second garden was a stepping-stone that was made to reinvest the capital from their first house

20

whilst Frances and her husband Andrew found a new place in the country. Metaphorically speaking, Frances has always seen beyond the boundaries and wanted to garden without them. She has always encouraged me to do that too and Home Farm allowed me to cut my teeth in a generous setting, with the wider site very much in mind. I had the luxury of doing this over time and without inhibition.

Today I live and garden in London, which is a stark, yet inspiring contrast to my early beginnings. I have created an oasis here in the garden in Peckham that is little to do with the city, more an escape into my love of plants. It is a sanctuary and a think-tank. Vicariously I am able to tap into things on a bigger scale with my clients' gardens and through them I can be part of environments that I would never have access to from day to day. The key to these gardens, and the thing that unites all of my work is that they are all attuned to the sense of place. In being so they capture something of the experience that I first felt at Hill Cottage, something real and potent, a sensitivity to place that heightens your responses, grounds you and places you in the moment.

BEGINNINGS

## PAINSHILL PARK

I first heard about Painshill Park in the early 1980s at an evening lecture whilst I was a student at Wisley. I had seen the tower on the other side of the A3 lurking in the trees across from the Wisley gardens and had often wondered what the building belonged to. I was intrigued to find that Elmbridge Borough Council had acquired one hundred and fifty-eight acres of Hamilton's original estate and the work of restoring the park and its many features had yet to be started. So the next weekend I jumped the fence and, to my complete delight, was able to discover the forgotten garden for myself.

The Honourable Charles Hamilton, who like many of his peers at the time had gained an education on a Grand Tour of Europe, had originally developed the park between 1738 and 1773. The garden took its inspiration from his travels and was one of the first to belong to the English Landscape movement of the 1730s. The movement saw a radical shift away from geometric formality towards a new naturalism. The paintings of Claude and Poussin and the ancient history of the Greeks and Romans were fuel to the storytelling in these gardens which combined with their composed naturalism to create a new form of escapism. Until the Second World War the park belonged to a succession of private owners but in 1948 the estate was split up and sold in separate lots for commercial uses. The park, as such, soon disappeared and its features fell into decay. By the 1980s, when I entered the park for the first time, it was on the verge of being lost for ever.

Here was a window into the life of a garden on the very brink of being lost entirely to nature. I pushed through the thickets of undergrowth for quite some time before coming upon a blackened lake, silted and oily-surfaced and encroached upon by saplings that were marching from the margins. Previous generations of trees had long since collapsed into the water to form a latticework of decaying branches. I had a handful of clues as to what lay in the undergrowth but I had no idea, when I sat disorientated but excited on a fallen trunk to eat my lunch, that lurking just above me in the overgrown laurel was a crumbling Gothic Temple. I came upon it quite by chance having decided that the ruins I had heard about in the lecture were not to be found. The structure was standing but decayed, the tiled floor visible through a thick pile of leaf mould when I dug with my boot.

Down by the river I came upon the remains of the waterwheel that had once lifted waters to the lake. It lay in pieces amongst the shoulder-high balsam. I tried to locate the cascade but couldn't, but as I got into my stride, each find encouraged the next. The ruined abbey that had once stood at the base of the vineyard had lost its reflection in the water now that it was shrouded in saplings but the Roman plunge pool was clearly visible under one of the largest of the Lebanon cedars. I had seen the trees several times, their ragged tops poking clear of the woods alongside the A3 but I had no idea how vast they would appear when standing up close. Limbs had been wrenched clean off by storms and lay discarded about them. On that first trip, I glimpsed the mouth of the grotto on the island but the slippery plank that had replaced the long gone bridge was far too treacherous to risk the passage.

I decided to base my thesis on the park and spent my spare weekends discovering the landscape that Hamilton had struggled to make over the time he was there. The garden had bankrupted him in the end but not before he had created something considerable: a story in landscape with melancholy lows and moments of elation. It was interesting to see how fragile this dream had been and how relatively fast the natural habitat had tilted the romantic vision. In truth, in its neglected state, aspects of the garden probably looked more like the Claude and the Poussin paintings than it had done in Hamilton's lifetime, but there was a fascinating tension here too; the delicate balance that comes when the hand of man is still visible but when nature has the upper hand. You had to imagine the grand vistas across open water to the Turkish Tent on the Hill and the alternating highs and lows created with walks through light and shade, but enough was there for you to be able to be part of the story. It was just that the story had changed as the grip of nature tightened.

The Painshill Trust was faced with the dilemma of how to go about disturbing the ecosystem that had developed there in the years of neglect. Trees that were rich in habitat for woodpeckers and a host of other flora and fauna were also perilously dangerous and the ivy that adorned the buildings was in danger of claiming them for good. The decision was made to clear the garden and to restore it to Hamilton's original vision and I left it twenty years before returning because I felt it would have been too painful to see the mood I had been so lucky to be part of, pulled apart to give the gardens a new life.

When I did return, the buildings that I had seen in original illustrations, but had long since rotted away, punctuated the vistas. The vineyard, that produced rather fine champagne in Hamilton's time, had replaced the forest on the southern slopes. Standing in the newly restored Gothic Temple, the sweep of ground where I had sat eating my sandwich was restored to grass, the view to the Turkish Tent was clear as it had been intended. The lake has recovered its reflections and, edited back to the key trees, the island is once again visible. The remnant cork oak, a survivor from the original collection, stands today likes a centenarian amongst youngsters in the amphitheatre.

The grotto had been lost in the war when ammunitions that were being stored there exploded and collapsed the roof. Artisans have been painstakingly restoring the structures with oak frames clad in spa stone as they were originally, and you can feel the magic again, with the light from the lake bouncing into the cave to illuminate the ceiling. But everywhere you are painfully aware of the effort it has taken to reverse a natural process in order to get back to this point.

Gardens are fugitive, they are at the whim of the gardener who is gardening them, or in the case of Painshill, the decades of neglect when the resources were absent and the dream lay unkindled. In truth, though I can see why the decision was made to restore the garden for historical reasons, something of the magic has been lost in the process. It is a dilemma, for gardens are always in flux, always shifting from one state to the next. The challenge for the next incarnation of Painshill will be to strike the balance between the dream of this romantic vision and the reality of nature's all pervasive influence.

## JERUSALEM

Whilst studying at Kew Gardens, I started to travel further afield to look at landscapes in northern Spain and the Himalayas. These trips unlocked a new way of seeing that took me beyond looking at the plants as individuals but as part of a community, a direct result of their conditions, the climate and the geology. After finishing the Kew Diploma in 1986, I won a scholarship to work for a year in the Jerusalem Botanical Gardens. I wanted to live four seasons in another climate, not simply dip into them, and I wanted to understand how the plants adapted to a land so contrasting to that of my own background. It was a year that cemented a new relationship with landscape and it opened up a further understanding about the way in which the components of a place come together to create the spirit of place.

The climb from Tel Aviv to Jerusalem took us through Mediterranean scrub where olives, and scantily-clad pines punctuated aromatic cushions of lavender, rosemary and broom. The city, which on that first evening was bathed in golden light, sat at the apex of the ascent and we travelled

through it to look down into the Middle East, where the descent gave way to an altogether more alien and pared back landscape. Goats grazed apparently bare hillsides and the light fell over ground uninterrupted by vegetation.

It was October when I arrived and though you could see that the land had been seared by the summer, the heat had all but gone from the sun. The nights drew in fast from that point and you had to rely on a paraffin stove to keep the chill at bay after dark. The rains, to my surprise, came by the deluge, sheeting over roads and swilling out the gutters, and with the water came the growth of magenta cyclamen and vermilion anemone. It was a short but certain winter and with each day that passed, a new green began to swell in the hills.

Michael Avishai, the then director of the Botanical Gardens, was a great inspiration for the way in which I began to use my spare time. Quite out of the blue, and usually towards the end of the working week, he would announce that the next day he would be leaving at four in the morning to go and find a plant that might or might not be responding to the winter rains. Our destination would be entirely dependent upon what was potentially in flower that particular weekend and he would arrive to pick me up before dawn. He would insist on winding up the windows to avoid drag on the car and these trips were some of the fastest and most hair-raising journeys I have ever experienced. These excursions took us to the heart of things and it was an intimate introduction to the land and its diversity.

I saw the shrinking Dead Sea emerge out of the twilight, the pillars of salt that marked its retreat thrown into relief against the salmon pink mountains of Jordan. We ventured into territories I would never have dared to enter had I been on my own. We tiptoed from the car around areas ringed by wires and signs warning of mines. We followed the dried-up gullies (or *wadis*) where the run-off collected after a storm high up in the mountains. Here, you could read the seams of underground moisture mapped in wild pistachio and where the *wadis* had been in spate they sometimes took the roads with them. In the south, the dusty acacias, with their inky dark shadows sat horizontally in the glare of the desert and told you in no uncertain terms that this was Africa. There were fossils of ferns in the rock and against the odds the occasional frond,

a remnant from another era. On another occasion, and in search of the elusive michauxia, we drove up to the Lebanese border through the rubbly but verdant meadows of the Golan Heights. A plateau of giant fennel and lime-green euphorbia rolled on for miles against the rusty backdrop of Syria.

On the weekends when Michael was with his family, I would catch the bus before Shabbat to find a new location where I would be stranded until the buses started running again after Shabbat was over. It was a slow but sure getting-to-know, and I learned to read the landscape through the geology, the topography and in the map of plants that were adapting to it. As I learned this language, I started to see how one environment affected and was influenced by the next and that in turn everything was interconnected. I started to see beyond the boundaries and below the surface. I learned the importance of stretching my eye whilst always remembering to look into the detail and the range of components that come together to make a place specific. This period, which was valuable for the ritual of returning to a landscape every weekend, built upon and informed a way of seeing that to this day I am still refining. It will be landscape that I go to first to try to understand the essence of an unfamiliar space but the same rules of observing apply to a cityscape or the interior of a garden.

In January, the almonds were already blooming in Jerusalem and I noticed a change in the folds of land that fell away in the descent down to the desert. They were slowly turning green, first on the cooler flanks and then, moving up from the valleys to transform what had apparently been nothing more than dust and dirt. I asked Michael when spring would come and he said emphatically that spring lasted from the 15th March until the 15th April. I do not know today whether this exacting timeline still applies but sure enough, the winter growth had gathered a momentum that tipped into an extraordinary spring once the middle of March fell. The stubble of green that had amassed on the previously barren slopes began to flare with colour and, in perfect unison, the pokers of giant fennel rose out of their filigree mound of foliage like an army holding spears up to the sky.

Spring happened on a scale that I had never seen before and slashes of scarlet poppy followed the lie of the land where the conditions were right. In turn, other ribbons of colour traced the veins of land that favoured them to weave together in a series of waves that pulsed and peaked and shifted as the weather warmed. Acid-green euphorbia, apricot peas, crimson adonis, golden cornflower and the palest lilac crucifers. The landscape shimmered for the best part of a month.

It was a shock when the heat was suddenly in the sun and, in not much more than a week, the grasses rose up and everything went to seed. Almost immediately the land was parched again, but over that year I learned to love the dramatic reduction back to the absolute essentials. The light, the intensity of contrast in the shadow and the process of learning to retrain your eye was a revelation.

## A GOWER WALK

It was one of those Easter weekends that tips one season into the next. Clear, blue sky and not a breath of wind. We were staying at Jane's cabin, one of several home-made buildings that nestle into the base of the hill on the Gower Peninsula in South Wales. There is a spring in the woods for water, a Portaloo out back, a tiny wood-burning stove for heat and a makeshift kitchen on the porch. Everything has to be hauled some distance from the car park and down a precipitous hillside. This, and the fact that you are not officially allowed to live here, keeps things simple.

This is a magical place because so many environments come together here. Woodland, cliffs, sand dunes, an oxbow river, marshes with wild ponies and the great expanse of the Atlantic Ocean converge in the space of a few square miles. The walking is good because nature is immediately outside the door and in the course of a day you can move through a range of habitats that are rarely found in such close proximity.

The presence of man in the landscape is light and kept this way very deliberately as it is a fragile ecology that requires respect. The lightness of touch manifests itself in well-trodden tracks that, in places, are hard to tell if they are made by animals or man. From the top of the bluff you can survey what you are about to experience, and see the desire lines marked in the sand dunes below. From here you make your choice as to which path you are going to follow; sea in one direction, the base of the limestone cliffs in the other.

Being part of an environment and moving through it on foot is one of the best ways to read the land and to understand the delicate balance that is struck between one habitat and the next. Everything has its place and the way that they come together and are revealed is often more perfect than any

garden could ever be. This is where you learn about the relationships between ecologies and their underlying geology, about the way the land reacts to the wind and the resulting balance and space. I look to these wild places as much for inspiration as for the joy of being grounded there and able to cast aside the distraction of the superfluous. It is in these moments that you are most in touch and most able to experience the mood of the place.

The trees were showing the first signs of life at the edges of the dunes where the blackthorn encroached from woodland. New grass in the shelter under the scrub, the first scrolls of the shiny hart's-tongue ferns throwing light back from shade. The blackthorn was in just-opened bloom with the darkness of woodland and ivy behind it to throw it into relief. These meeting points between habitats are always the most dynamic, with one shifting into the next and the two coming together in a rich hinterland. Underneath the sheltered caves provided by the blackthorn's wiry growth, were primroses in moss, thriving and luminous in captured leaf mould. There were violets here too and in the shelter released by the sun that was still able to penetrate the bare branches, the perfume of both was captured.

The modesty of the tracks that snake from one space to the next are key to the feeling of being allowed into nature. They are little more than one person wide and in places have developed simply through a desire to move from here to there. In other places, where the passage might be wet or precipitous, they have been fashioned from local materials that are part of the place. A dry-stone wall to direct the passage might give way to simple stone steps to mount the hill. Wooden sleepers are laid over the delicate dunes. A simple bridge of silvered planks couldn't be better fitted to the salt blasted marshes. In rare places on the walk, seats are provided as resting places and these help focus the eye, but once your eye is attuned to the environment, you start to see without help. A fallen log will replace the seat, a clearing under a pussy willow where ant hills have been colonised by close cropped fescue grasses, provides a cushion. You want to stop here to sit and to take in the clearing that has been formed by the shade of the willow.

A GOWER WALK

When you do stop, your eye can appreciate the richness of colour and texture. Dark, wind-twisted oak branches backlit by sepia reed beds and pale sculptural driftwood consumed in a sea of vertical reeds. On the horizontal of the marshes, framed by the upright trunks of an alder colony are rust-brown sedges. Dagger-like spears of iris cut through mud here with fleshy samphire. A roundel of dark pines punctuates the horizon line.

A natural garden comes together at the edge of the marshes where the rabbits have formed clearings by cropping the grassy mounds that were once shifting sand dunes. Light-laced groups of birch feather the margins and to the landside, dark pine woods repeat spacious verticals. Stinking iris has found its niche here, the simple ground cover forms a resting point for the eye and a change in pace. You enter the pines from the blusteriness and light of the dunes and the woods are dark and still and smell of resin. The walk has been a string of experiences, each connected and easily pulled aside for future reference, but collectively a passage that has held you completely in the moment, allowed you to be part of the place.

The Pleinmont Fairy Ring, Pezeries Point, Guernsey.

**MANAGED LANDSCAPE**

Britain's is a landscape altered by man. There is very little, if anything, that remains untouched and primitive within it, and its sense of place has been generated as much by the hand of man as by the way in which nature has responded to the management of the land.

Where a primitive place such as the untamed tracts of land in New Zealand might appear threatening, in that it is inaccessible, untrodden or untamed, there is a certain security in a natural environment that in some way has been steered by man. Human interventions offer a way in, or provide a route that can be followed. In the tension between the tamed and the primitive I find much inspiration for arriving at ways in which a wild space can be made to feel accessible.

Much of the comfort drawn from the visible intervention is down to contrast: a swathe cut through reeds that allows you to be part of a place and to be intimate with somewhere that at first might appear impenetrable. The cut path offers security and with it a whole range of sensory experiences that enable you to feel part of the place: the rustle of wind in foliage, the feeling of immersion, the damp, still air in the enclosure.

The most interesting interventions are often the most subtle: a dry-stone wall in the Burren, made from the same materials as the limestone pavement, which, one discovers, bears the signature of the man that made it. Like handwriting, the walls bear the mark of their maker. Herein lies a tension that makes the natural that much clearer for what it is by providing it with a boundary, frame or reference point.

Most of England and much of Wales and Scotland has been altered by farming. Forest cleared many centuries ago has given way to land that is parcelled and segmented by walls, hedges or fences depending on which local materials were to hand. The topography and in places, the geology is revealed. Chalk coming up to the surface on winter-ploughed downland, crops transforming the hills to change them, sometimes quite dramatically, from season to season. In this combination of the land, what chooses to grow there and what has been encouraged to grow there, we find the identity of a place, altered like a garden, but rolling from county to county and shifting as earth or rock, city or water comes to the surface.

## ROUSHAM

Rousham is restful, spacious, timeworn and beautifully paced and whatever season you visit, the garden always reveals something afresh. Charles Bridgeman's design for the gardens was originally completed in 1737 and shortly afterwards General James Dormer commissioned William Kent to further enhance and carry forward the garden. It is remarkable for the fact that it has remained in the same family since then and it is one of the first landscape-gardens to blur the boundaries between the garden and the pastoral English countryside beyond.

The managed land of the adjoining farm sets the scene and the bucolic views form the backdrop to a stylised interpretation of the English landscape within the garden's boundaries. A *ferme ornée* that was remodelled in the style of the main house sits out in the fields beyond the river so that your eye can travel and make this connection. The river is all that separates the garden from the flood plain to the north and a ha-ha allows livestock to come within spitting distance of

the house to the west. This dialogue between garden and landscape is constant as you move from space to space. The way in which you are lead from one space to the next is key to its magic. Sometimes you are coaxed from one mood to the next by your eye and the draw of a focal point, sometimes, where the mood is more intimate, tiny gravel paths, just wide enough for one person, guide you like an animal track.

In the wilder parts of the garden, the experience bears many relationships to a walk in the countryside but you are introduced to that slowly. There is graciousness about the beginning of the experience that encourages you to look up and out and you are introduced to the way of seeing in a gradual, airy manner before dipping into the garden more intimately.

Peacocks and tufted bantams run free at the entrance. There is a handwritten sign indicating that children are not allowed but picnics are. You pay at an unmanned ticket machine and proceed from the stable block where you have deposited your car as you would have done your horse in the eighteenth century. A monolithic hedge, which is like a building in itself, separates you from an oval lawn with steps up to the ungarlanded formal front of the house. A window opens up in the limes to reveal the drive down which you came and you move on around the corner of the house as if you are sneaking about, or trespassing. This is where the ha-ha comes closest and you pass by a tiny conservatory, which is the only concession to gardening in this first chapter of the story.

As you swing around to the north, a formal lawn is dropped slightly below a mossy gravel apron from which the façade of the house rises without hesitation. The views out and over the land below introduce you to the connection with the landscape and, although they set the scene for the informality beyond, the lawns in front of you are the most formal element that you are to experience. The ground in front of the house is spare. There are no borders, the building meets gravel. The gravel

is mossy in the shade and crunchy out in the sun where it moves away to frame the formal lawn.

A monumental, matt yew hedge with the occasional flash of light-reflecting holly lies to the side. It bears its age in its billowing forms and is dark and heavy. A junction, like a joint in a limb has within it a tiny hole that is the size of a door but dwarfed by the volume around it. You are drawn to the break of light to glimpse the walled garden beyond. This is dramatic separation, a play of scale that pushes you to explore the world beyond it. Inside the hedge and twisted over time, a network of branches supports the outer skin of greenery and it takes a while for your eyes to register the extent of the inner cavity moving away into a tunnel of darkness.

The walled gardens, which sit privately behind the volume of the hedge, are vast and only partly gardened. There are two areas and the smaller of the two is where most of the produce is grown today. The walls are made from brick, in pattern, and overlaid by centuries of lichen. The well in the grass is positioned for practicality by the door between the two enclosures and the stone surround to a doorway is flared at the height of a wheelbarrow. You wonder if it was built like this or has it been worn away? The paths, that lead from the doors in the wall, lay out a formal system of easy-to-access routes but they have crept over time so that they are no longer straight or in the original alignment. Being out of true is half their charm.

Fan and cordon fruit trees line one section of the garden that is otherwise empty. They are each different. The roses like a crest, the pears gnarled and angular. Care, time and order are marked in each of their limbs. Ancient apples line pathways where beds once were. Each has their own character. Some trees are rotten and hollow-trunked but still productive. The gardening feels real here. Nothing is perfect.

A Gothic arch in a box hedge, smelling catty but of gardens, leads you to steps up into an orchard around the dovecote. A well-trained cherry wraps the curving walls of the dovecote to the north side and a pear catches the warmth where it falls to the south.

ROUSHAM

ROUSHAM

Engraved into the dovecote is the date, 1685. Your eyes need time to adjust to see how the birds were organised, and the construction within is beautifully crafted. The birds were reared for food when this building was erected and today the floor is soft with decades of accumulated guano. In the spring, the ghosts of trees that once stood there are marked in discs of aconite in the grass. There is an odd collection of things in the garden around the dovecote: stone sinks encrusted with pinks and rockroses; incongruous yuccas from the last century; a hot, scented wall with seats amongst lavender; a rose parterre. The furniture is a rich cream and it has an Alice-in-Wonderland feeling about it where it is scattered under pale magnolias on the grass. This dreamlike feeling is carried through into the neighbouring churchyard where the topiary yews that line the path are like spinning tops with rounded crowns, straight sides narrowing sharply from the waist down. They are each slightly different and cast their elongated shadows onto the grass, framing a view out into the pasture beyond. Primroses have hybridised here over the centuries into a collection of pinks, whites, mauves and yellows as varied as the lichens on the walls.

Back out on the ordered lawns, you are drawn to the formality of a statue that stands at the catslide of land at the end of the upper terrace of lawn. But here your eye refocuses to take in the *ferme ornée* and with that you leave the formality behind. If you are not already facing the landscape, the paths manipulate you so that you turn your back on the grandeur of the lawns. The paths are narrow and immediately naturalistic and you are encouraged to walk alone or in single file. Here the path divides: one route funnels down into the darkness of the shrubbery, the other takes the walk along the ridge to take in the pastoral views over the ha-ha. Although it is said that Kent had his own predetermined route of the gardens, I have not decided which I prefer. It is good to have choice as the chapters are unravelled quite differently depending upon your decision.

If you plunge into the darkness of the yews and the carpet of inky ivy that leads you down the hillside, it comes as a surprise to swing into the light again and find the formality of the belvedere. It is framed by large, neoclassical urns and, from within the building, you realise that it is orientated to frame the view of the water meadows and the river below. This view forms a more intimate meeting with the river as you are nestled into the hill and the yews to either side frame the water beneath you. The pace changes again as you are enticed down the slope along lines that are drawn into the soft turf-like chalk marks on a plan. These paths are again single-file narrow and seem to lead you towards a formal archway in the trees where Apollo is framed against the light. But the path leads you down and away, into the trees alongside the river. This is a garden that beckons you very gently. There is no pressure to be directed, the paths are a gentle accompaniment that are the equivalent of being lead by the elbow. The river slips silently by. It is profoundly silent and separates the garden from the borrowed view.

You move through the trees against the flow of the river. The play of greenery and the use of light is key to the experience. Clipped laurel is used like a thick pile carpet to cloak contours of the understorey, its shiny foliage bouncing light in the shadow. Dead wood is left standing like it might in a wild wood and heightens the melancholy mood. In contrast there are young saplings nearby and all generations are present. There is a feeling of gentle manipulation in the garden, not rigour. The trees are opened out to allow light to fall on grass in the clearings and as you swing up and away from the river a pavilion greets you on the rise and then to your side, the statue of Apollo. These events within the garden draw your eye and then your passage. They give scale and context. As you stop to take them in, you once again notice the river beyond as it enters the frame under a bridge in the distance.

The rill emerges in a gap in the trees to the left. It is supremely minimal, like a rivulet in a wood but drawn, like a pencil line into this landscape. The sliver of water snakes away and draws you into the trees. It is completely modern and timeless. Dark yews cast shadows so that the water in the rill glimmers as it picks up the light. The water is green under the canopy but silver where it emerges into the open and you follow it as it murmurs towards a break in the cover. Emerald green laurel lightens the mood around a bathing pool where the water slows and is held still before moving on. It is completely enticing and you want to strip and plunge to feel the water on your skin. The octagonal form is unexpected and it formalises this clearing for a moment. You move on into darkness again as the path snakes through the arc of foliage that frames the walkway.

You can never see the whole rill at once. The silence is only broken when you emerge into light and the rill drops into the still of the lily pond. This is the first sound of running water, a contrast to the silence of the river, and an echo is held in the bowl of the hill in which the lily pond is settled. The lily pond is held in the slope. Square but round edged. Cushioned by banks. The water is reflective out of season. There is the luxury of water lilies in the growing months.

You rest here to take in the soft depression at the head of the little valley. Your walk unfolds in your mind's eye whilst you ponder whether you want to make your way back into the real world.

ROUSHAM

ROUSHAM

# CHELSEA PHYSIC GARDEN

The Chelsea Physic Garden was established as the Apothecaries' Garden in London in 1673. It is the second oldest botanical garden in Britain (after the University of Oxford Botanic Garden, founded in 1621) and is still something of a well-kept secret. The garden was originally placed by the Thames for easy links by water and the warming influence of the river increased the range of the collection. Though today it has been severed from the water by the Embankment on the southern boundary, the surrounding walls and its south-facing aspect still mean that you can find Rosa 'Bengal Crimson' in flower at Easter, lofty echium poking their heads above the walls, and there is the largest fruiting olive in the country and a grapefruit that produces and thrives without cover in the microclimate.

Like all walled gardens, another world is contained within its confines. As a garden, it has its eccentricities and there are a series of environments for supporting different types of plants. A sombre fernery sits in the shade on the western boundary and there is a Grade II-listed rockery dating from 1773 that is thought to be the oldest in the country. It is constructed from a variety of rock types: stones from the Tower of London, Icelandic lava and fused bricks and flint. There is a sunken pond, narrow paths through beds of aromatic winter box and order beds exhibiting neatly arranged plants grouped to show their botanical links and variation. There is also a slightly shambolic air despite the obvious love and attention that has gone into looking after the garden. You can see the work of one generation of gardeners overlapping the next in beds that have lost and regained or are losing their themes according to how well particular plants have grown.

Certain days of the year are marked by events that draw visitors into this oasis off the busy streets nearby and I love the gentle enthusiasm of the people who also treasure the opportunity of being here. A snowdrop theatre displays a collection of galanthus in February, there are plant fairs in the summer and a very good café with excellent cakes that you can eat in civilised fashion on the lawns. This is England at its best. Though the Physic in the Physic Garden originally referred to the science of healing, the meaning can be extended today to describe a place that will change your mood for the better. Step through the garden gate and another world awaits you. You leave feeling grounded and replenished.

# TREES

I was brought up in a clearing on a forested hillside. The natural state of things was governed by the trees, which would seed into any ground that had been taken back to bare earth. Our own garden (which had originally been cut out of the pine, birch, beech and oak) had seen a good fifty years of this recolonisation before we moved there and only the fittest and most dominant plants remained from the old garden. If one of the elderly trees toppled, it would be bramble and nettle that would take over first, creating the shelter for the pioneering birch and wild cherry that unwittingly acted as the nurse crop to the slower growing pine, beech and oak that followed.

The vast Turkey oak, originally planted by Miss Joy, had claimed the centre of the garden and we lived with its constant presence throughout the year. From its stout roughly-textured bole radiated a dome of branches the best part of eighty feet in diameter and you could make it out from the other side of the valley. Its limbs came within feet of the top windows of the house so that from the bedrooms you felt as if you were in the canopy. Winter sunshine picked out tree creepers and woodpeckers foraging for grubs in the branches and the ground beneath was overlaid with limbs traced in shadows. Come the spring you could feel the sap rising as the buds swelled and then broke in a spectacular week-long metamorphosis. We were then plunged into heavy, dappled shade for the summer months, but autumn saw the cycle completed with the light gradually becoming stronger again as the leaves fell and mounded into drifts.

There were other trees in the garden that also made their impression. The tall Scots pines roared in high winds and their ruddy trunks flamed red in the evenings as the setting sun caught them. The twisted amelanchiers with their downy, coppery buds, the wild gean and old twisted apples in the orchard erupted in a froth of blossom to illuminate spring after the dim winter months. Despite their age the trees in the orchard fruited heavily, one year off, the next on, to leave the orchard smelling of cider. There were too many windfalls and they fermented where they had fallen. We had makeshift tree houses made from planks, and rope swings in suitable branches. Most of my childhood was lived in the shade of the trees or up in their canopy and now that I am in my forties, I have made it my mission to plant them wherever it is fit to do so.

It was a great honour to be given the title of Tree Ambassador by the Tree Council and my responsibility there is to do no more than promote and enthuse about them. This is easy. Each winter several thousand native trees and tens of ornamentals are planted as a result of the work that comes through my design studio, but you have to employ foresight when planting them. Put them in the wrong position and they will overwhelm future generations, plant without thought for the environment that is already there and important habitats may be lost. Eucalyptus plantations introduced as a cash crop in southern Europe are dropping the water table with their questing roots, and their foliage, rich in essential oils, is poisoning the indigenous flora and soil. These introductions also look wrong in the landscape, creating a kind of botanic globalisation where it is impossible to know whether you are in Australia, Spain or California. Trees are also costly to take down both in terms of money and social attachment. Though a tree may well be in the wrong place in terms of practicality, it might not be in the hearts of those who have come to love it.

Though the natural state of things in this country would once have been forest, the habitats that have evolved through their removal are often richer and more varied without this dominant layer. Meadows created over thousands of years by grazing and haymaking and the edge of woodland hinterland are necessary places if we are to have a wealth and a diversity in the ecology, so when you plant a tree, you have to think about these contrasting environments to keep the balance.

It has been said that men plant trees in times of social stability, but today we have to take an active role in their protection and proliferation, as our apparently stable society seems to have forgotten that trees are one of the keystones of life. They may make an invaluable link with the past, but they must also provide us with a sense of provision for the future. In order for this to have meaning, and the best consequences for life on earth, we must ensure that we act correctly now and take responsibility for planting trees with a full understanding of our intent and the consequences.

We have been excising the green lungs of the rainforest at our peril. The discovery that rainforest canopy ecosystems are rich in untapped medicines should hardly come as a surprise if you have any belief at all in herbal remedies, and there is an irony in the prospect that medical commerce will now become the motivating factor behind the impetus to preserve what remains of them. Though the idea that we can compensate for our carbon footprint by offsetting it with massed tree planting seems little more than a knee-jerk salve to our consciences, it is a step in the right direction.

The role played by trees in pagan culture, as in all animistic belief systems, was central and with good reason; their longevity and hardiness in the face of tempest, fire and flood is a constant humbling reminder of human mortality. The tortured bristlecone pines, that have found their niche amongst the erratic strewn rockscapes of Yosemite, may be no more than a few feet high but they can live several thousand years. Your existence feels ephemeral and fleeting when you stand beside them in the knowledge that they were already here when Christianity first took hold of the west.

TREES

The scale of the General Sherman, the biggest redwood in the world, is difficult to grasp when you stand at its base. Despite its size, it is completely dependent upon the ecosystem in which it lives: a small slice of California where the sea mists keep the air moist and cool. There are very few of these giant trees left since the loggers removed them in the nineteenth century and their stumps are still intact in the half-light of the forest. We would never fell such a tree today or carve a tunnel through the trunk as a novelty, but we are fascinated by the idea of being so close to something so powerful.

Once I was taken into the rainforest in Malaysia and suffered a profound claustrophobia in the relentless heaviness of green. There was no way out, no hope of a let-up with a shift in season, because here there were no seasons that would allow the light down to the forest floor. On looking up, however, I saw a group of trees that had accommodated each other by creating precise individual spaces, each of their canopies interlocking like the pieces of a jigsaw puzzle. Despite feeling overwhelmed, it was seeing and understanding that there was a balance here that allowed me to relate to it more openly and without fear.

Trees capture a mood and give a place identity. The dark stasis of yews in a churchyard imposes melancholy, despite the fact that they were planted as symbols of eternal life. It is prudent that they are now believed to be able to live for nine thousand years or more. Yew was used to make longbows and arrows, the arrows fatally tipped with yew poison. The lore surrounding them has always mixed fear of death with the promise of longevity and resurrection and it seems fitting that the red aril of the fruit is sweet, the inner seed a deadly poison. That said, the extracts of yew toxins are now providing one possible treatment for cancer.

Looking across a landscape, it is more often than not the trees that help you to read the environment. The hypnotic silver shimmer of willows goes hand in hand with water, and harnesses an unseen element in the wind. The lines of poplars marking the polders in Holland provide vertical framing in an otherwise horizontal landscape and guide you to the location of canals, roads and settlements. On the windswept tops of moorland or by the sea in Britain it is the hawthorn and blackthorn that show the direction of the wind. In the sea and near desert landscapes of Southern Spain, it is in the black pool of shade under carob and fig where you want to be in the white-out light.

Trees clothe cities to make them less hostile. They are the green lungs where air is polluted. They give land identity as in the white birch forest emerging from snow in Scandinavia, or the dark coniferous woodland of the foothills of the Himalayas, where the ground is populated by hooded arisaemas. A glade of katsura trees in Hokkaido scent the air with their curious smell of burned sugar when the foliage is wet, while on the Devon coast the lichen- and moss-encrusted trunks of ancient oaks are gnarled and distorted by the sea winds. In all of these environments it is the trees as much as the habitat they respond to that help to forge the atmosphere of these places.

TREES

58

Trees mark time in themselves but their response to the seasons also marks out the year. The Japanese have planted cherry groves for centuries to celebrate the passing of winter and Hanami (the cherry blossom festival) is celebrated the length of the country with blossom forecasts appearing on the news to chart the waves of flower as they move north. Parties are held in parks and gardens and braziers are lit under the canopies at night to illuminate the moment when bud breaks to flower. I like this moment of anticipation and will savour the gentle drama of the transformation. A tree in flower is like a life change for the better. It will make people smile and put them in the moment.

Autumn is celebrated in Japan with the blaze of red maples. These are planted singly in the tiniest courtyards to capture the moment, and en masse so that whole skylines blaze crimson. In the relative confines of my garden in London, it is the *Cercis canadensis* in its giant pot that keeps me in touch with shifts in the year. Tight buds of sugar pink flowers line the branches in spring, while in autumn its heart-shaped leaves are infused flame red and orange.

The art of bonsai could easily be seen as a perversity, the potential of a tree kerbed by such attention, the tree reduced like bound feet or birds kept in a cage. The dependency upon their maker is an aspect of garden making that I find unsettling when so much of the wonderment in the art of growing and tending is in the act of nurturing. But the idea of a tree caught in miniature is an extraordinary one, which confounds our sense of scale and makes us believe that this tree has been weathered by time and circumstance. Many of the most famous bonsai are hundreds of years old, handed down from generation to generation. The discipline can only be seen as something that requires a second take, an intensified engagement. A step back from the way that you normally see the world.

TREES

## JAPAN

I have been visiting Japan twice yearly for over a decade now, first to create a series of rooftop gardens in Roppongi in Tokyo, and then to work with Takano Landscape Planning on the masterplanning of a two hundred and fifty hectare ecological park in Hokkaido. I have been given free rein there as a designer and encouraged to express my fascination with landscape and the sense of place. The aim of the project in Hokkaido has been to create a series of spaces that entice the visitors out into the landscape and to ground them in their environment so that they can interact with nature in an intimate manner. It is a conservation project with a plan that it will be sustainable for a thousand years, so thinking has to happen on a big scale with an eye on the future whilst designing for the here and now.

It has also been an interesting exercise in scale and I had to immerse myself in the landscape in order to design an earthwork that could link the flatness of the plain to the mountains. This undulating area of grassland imitates the forms of the horizon line, reshaping the foreground into a series of foothills designed to coax the visitors out into the grounds. The earthwork plays with light, form and volume and rolls over five hectares. It connects a forest garden where Takano has created a children's playground with a new perennial garden that I designed to draw visitors, who might need the comfort of a garden space, to make them feel comfortable in the landscape. Thirty-five thousand perennials are grouped in an almost completely freeform matrix to emulate the woodland flora found in the forests there. Many of these plants have never been grown in Japan before let alone treated in such a manner. It is brave stuff that you might not at first associate with a land that has a reputation for control, but I have learned to take the risks of working outside my comfort zone and so, in accepting the risk of the unknown, have they.

Working abroad has a way of allowing you to get under the surface of a culture. You are taken to places that you would never visit as an onlooker and as a matter of course you have to engage more fully with the way in which the society works. Although I feel very much the outsider in Japan, being a stranger allows you to look with a new eye and to feel the way where it might not immediately be clear. Being outside the comfort of your own culture can put you in the here and now more immediately and as I am so beautifully looked after, I have learned to be open when I am there. Japan has been a profound influence on the way in which I see things and though the cultural differences might not always be immediately clear, through time spent there I have been able to learn how to look at things through their eyes and understand to a degree the aesthetic. Each trip reveals a greater understanding that I have found immensely valuable. Few societies pay as much attention to detail or value the subtlety of things quite so highly, and the process of noting the colour, the form, the texture and the intent of the way it has been put together is key. These are messages that become clearer the more you learn about the culture and as the grey areas between the light and the dark are where the most interesting things happen, I feel incredibly lucky to have been shown, on occasion, where some of these areas lie.

Japan is a land of dramatic contrasts. Walking through the streets of Tokyo, it is impossible at points to see the sky uninterrupted by overhead cables. Though the traffic is calm and pedestrians wait to cross the road en masse, there are cacophonous pachinko arcades lined with gamblers that are an assault to the senses. The everyday person knows how to live well in a small amount of space but even the homeless wrap their makeshift cardboard boxes like a well-presented gift. The blossom festival of Hanami marks the end of the winter and the festival is based upon the idea of new life, but there are drunken parties in the park under the blossom-filled branches. Out of these contrasts come innovations like the play spaces designed by Takano Landscape Planning. A fog garden in Showa Kinen Park in Tokyo was the first of Takano's play spaces that I saw. It is an elemental experience, one that makes the children shriek with delight and one that encourages them to lose themselves in mist and to climb onto a grid of rectangular turf mounds that are based on a bar of chocolate. Each can be the king of the castle as they escape the fog that periodically fills the gullies.

Public transport is always on time and travelling in the immaculate bullet train – at considerable speed from city to city – the sprawl of suburbia appears unbroken. There seems an unbridgeable gulf between the order of the suburbs and farmland and the natural world that lies beyond it. Indeed there is no specific word for nature in the Japanese language.

top: Kan Yasuda Sculpture Park, Hokkaido.
bottom: Fog garden in Showa Kinen Park, Tokyo.

I am sure that this is why I should spend more time there to learn the language as it fascinates me that there seems to be such a dislocation between urban and rural life.

The towns and cities are highly organised, with every gap filled and ordered. Pavements, street trees and hedges are tightly maintained. Few things are left untamed and little it seems is left to chance. But though the culture might seem to be removed from the natural world, much attention is paid to the detail of natural things. In this rigour lies much beauty. I started recording my meals on my first visits and continue to do so today. A season is often displayed in a meal so that you are placed in the season or that moment, as in a haiku.

A bento box is arranged like a garden, each section a considered composition of texture, taste and colour. Ginkgo berries strung on a pine needle, a dish displayed on an autumn magnolia leaf instead of a plate. A salmon fin in hot, aromatic sake with a winter meal of blackened leeks, the centres soft when you break the charcoal skin. The ceramics might be unmatched and discordant so that each dish is seen as a separate entity, but there is always connection in the discord and the food is displayed like a poem. In an exercise in subtlety food will rarely be served hot should the taste be lost in the heat. Good food is appreciated by the time it takes in which to eat it, the setting and the company.

There is a constant appreciation of quality and craftsmanship. Gift wrapping, for example, is a skilled job in a department store, worked into a carefully choreographed series of movements: turn, tuck and fold, push the box with the stomach against the bench to get the paper taut, each a precise movement, to deliver a perfect result. Sometimes this attention to detail produces the quirky: gangs of teenage girls dressed as Manga characters; a restaurant window made from an aquarium filled with jellyfish lit with ultraviolet light. Supremely modern architecture such as the Prada building will make a space for itself rearing up unexpectedly through the undesigned packed-in buildings around it. You will never have seen an aesthetic like it. Take a closer look and it is like a crystal, the convex and concave panels of glass reflecting the light, the latticework of internal girders cream and sculpted smooth as bones.

You are never far from the handcrafted. Takano's woven macramé playground, like the lair of a funnel web spider, wooden chopsticks, rice wrapped in bamboo sheaths, indigo tie-dye. Shoji screens with paper over a frame of wood or bamboo, translucent, yet holding the light. Rooms are often darkly painted and low lit or lit with only natural light so that you have to take time for your eyes to adjust. Lacquer will reflect what little light there is. The Japanese are not afraid of the shadows or their metaphor and it is in the shadows that much of the communication takes place. I do not imply anything sinister; it is more an appreciation of the unseen, the spaces between.

The concept of *Wabi Sabi* is not something that I claim to understand fully but as far as I do, it has many parallels to sense of place and it has underpinned many of my most treasured experiences in Japan. When asked to describe *Wabi Sabi*, you will rarely get a direct answer, more usually examples of it that – when gathered together – point to a way of being in the world that is driven as much as anything by attention to detail and subtlety.

Broken down (though the two parts are essential to each other), *Wabi* describes a cutting away of the inessential and a simplification; *Sabi* points to a sense of change, or transience. This was described most beautifully by an elderly woman who talked about her essence as a person having shifted, over the course of her lifetime. She said her name now was the same as the name for the person she was as a young woman. She was essentially the same person, but time had changed how she was in the world. *Sabi* is often detected in the passing of time as marked in nature. Dew on a camellia flower might express this transience. A gardener might leave a leaf on the moss after a garden has been swept for the day.

I have been told that if it could be defined, it could not be *Wabi Sabi*, that you have to stop yourself looking and let yourself feel it. But it is possible to look for the clues, through asymmetry, in the random, the unfinished and the incomplete. In here lies the beauty of imperfection, a rustic ceramic apparently crudely fashioned or celebrated for the chance happening in the firing, the uneven, the haphazard, the crude even. *Wabi Sabi* is also found in an attention to others, and the ritual and serenity of the tea ceremony encapsulates the concept on several levels. A teahouse is a humble space into which you have to climb through a low window made small so that you had to remove your sword to be equal to your host. This window would not allow you views of the world outside. There would be low light here, imperfect ceramics, the whole environment pared back to a rustic simplicity. You would share the guest's feeling without a word being spoken. The taste of the tea itself is harsh, complex and imperfect, the setting, the time and the moment designed to concentrate you in the here and now. Some say that *Wabi Sabi* is found in the soul and if you do detect it, it feels like the antidote to the modern world.

right: Cycads wrapped for winter.

JAPAN 67

## ISAMU NOGUCHI

I have made it a mission to follow the work of Isamu Noguchi and seek it out when I am in Japan or America. He developed a career as a landscape architect in tandem with one as a sculptor, and though he is also famous for his paper lamps and lanterns, my favourite pieces are those that juxtapose the natural and the man-made world. They take the raw material, the crude and the unfinished, and contrast it with the same material altered or worked so that it is honed until it reflects, transformed just enough for there to be tension. Many of his pieces use weight and balance and light and darkness in their make-up, most use water or the suggestion of the reflectiveness of water in highly polished stone.

I see his sculptural pieces in rock pools and boulder-strewn landscapes but in his most ambitious work he goes a step further to sculpt the land, using space and form as his raw materials on a big scale. I have only seen the Moerenuma Park in Sapporo whitened out by snowfall but the ambition of this place is considerable and all encompassing. (It was completed to his masterplan after his death in 1988.) His landscapes have their own aesthetic and a mood that is particular to them. They are far more than a mere foil for the sculpture within them for they are sculptural environments in themselves.

The Sogetsu Ikebana Centre in Tokyo has an internal 'garden' that takes up the entire space of the atrium. There are no plants here, just the play of stone and water. A series of terraces is connected by a sinuous rill, which brims from the source-stone, moving mirror-like where the stone is smooth on the upper surface and then with texture down the sides of the 'vessel' where it is roughly chiselled. As you follow the rill, it moves you through the space, dropping between a coil of steel to resonate with a hum into the vessel that terminates its journey.

## HENRY MOORE 'LARGE TWO FORMS'

I must confess to finding the Yorkshire Sculpture Park a little uneven, since many of the pieces appear to have been imposed upon their setting rather than to be occupying it. There is so much to the placing of a piece with attention to space and light, while its juxtaposition to the bulk of trees or a building or the line of the horizon can combine to create a narrative. Good placing will ground a piece and in return it will provide the ground with a sense of place.

The best sculptures animate a space and focus your engagement, not only with the sculpture, but also with the detail of the world around them. I loved this piece for it took the space it needed, with air and sky and a continuous three hundred and sixty degree horizon in the sheep paddock. Moore liked to see his sculptures with sheep for they contextualised and animated their bone-like forms. Go to his studio and many of the pieces were inspired by the wracks of bones that he collected on his shelves.

At first viewing, this weighty form in the paddock reads as one monumental piece, but I took this sequence of pictures to illustrate the fracturing and reassembling that occurs as you move around it. The individual pieces frame and re-frame the view as it joins and dislocates. It has a primitive, monolithic quality and holds the ground with a convincing sense of gravity and connection. It has inspired animals and people alike to take shelter within it and, where it has been touched or rubbed, it has a patina. Within it you feel protected.

## ANISH KAPOOR 'MARSYAS'

*Marsyas* was the third in the Unilever Series at Tate Modern and in my opinion it has been one of the most successful, for its presence and as an exercise in scale.

Unlike many of the other installations, which battled to take occupancy of the Turbine Hall and make this vast space their own, *Marsyas* was a wholehearted inhabitant. It appeared to strain against the volume of the hall and in doing so altered the mood of the space, leaving you with an interesting sense of confinement. One of the apertures pushed at an angle within the confines of the box, like a seed straining for light. It held the space, took ownership of it, reflecting a meaty glow and casting its vast shadow where it swept to the ground.

Moving around the piece took its time and it took time to come to terms with the sheer scale of the construction. It had mythical proportions. The form was taut and elastic, measuring some five hundred feet from head to toe and spanning the length of the hall. The structure swept skyward over one hundred feet so that you had to tilt your head to look up into its recesses.

Standing on the mezzanine level of the hall, you had no option but to place yourself in the shadow of the sculpture, under its central ring, which hovered just out of reach. From this elevated position you could look out to the expanse of the shining exterior stretching to either end of the hall, but the suspended ring above focused you to look inward at the internal workings of the structure. The lip of the funnel above you created its own horizon line and there was a slow shift as the structure moved a tiny amount to remind you of its weight. Looking up, you were reduced to the size of an insect, caught within a vast flower or the internal workings of an animal. You felt weightless and there was no choice but to be consumed by it, to be a participant.

## YOSEMITE

I had always wanted to visit Ansel Adams country and to see the land that had inspired the great naturalists, Galen Clark and John Muir. It was November 2005 and we drove to Yosemite from Los Angeles via the Sequoia National Forest. It was an intense eight hours powering up the highway before the foothills loomed ahead and the fading sunlight glowed orange as we pulled up into the mountains. A sign announcing 'Take nothing but memories. Leave only footprints', announced our arrival. Originally credited to Chief Seattle, this phrase reminded me how much I admire this country for its attitude towards its National Parks. Vast tracts of land have been designated as national reserves and the feeling of respect for these environments is palpable and a marked contrast to the gas guzzling highways just hours away.

That night, as dusk fell, we saw our first bear and her cubs coming down to the car park to scavenge. The ranger who had joined us to take in the sunset, explained that the bears become dangerous, and a problem to people when attracted to scraps that visitors leave behind. Later we pitched up at the clapboard Wawona Hotel and saw the warning signs accompanying what looked like the picture of a car wreck behind the receptionist's desk. 'Do not leave food in your car. Do not picnic or carry food on your person!' The vehicle looked as if it had been opened like a can, the doors peeled back, the boot ripped open. Man and his attempts at control suddenly seemed at odds with nature, and the park felt small and far from the wilderness it must have been just a century beforehand.

The land on this first leg of the journey was famed for its redwood forests but despite the frequency of the 'No fires!' signage, the autumnal air was sweetly scented with the smell of burning conifer. We discovered later that this was a controlled burn that had to happen on an annual basis if the forests were not to become a fire hazard. In the past, lightning would have regularly triggered forest fires that cleared the brush. The redwoods, which are protected by their pulpy bark, would literally rise above the problem. We saw evidence of the fires in a blackened chimney within one of the trees, but not the clearings that would also have been opened up to allow pioneer species and the redwoods' own seedlings to proliferate. In the past, the aftermath of apparent disaster provided the window of opportunity for seedlings to find a niche in the nutrient rich ash. A flurry of diversity would rejuvenate a new generation of forest whilst also opening up another environment for the animals.

The Native American Indians who lived from the land, learned from the natural cycle and fired tracts of forest in controlled burns to create grazing grounds and habitat for hunting. At that point man would have been part of nature and in scale with his environment, but today, with the fear of fire, the landscape has changed. Previously meadowed valleys that were open ground when the first white settlers arrived just one hundred and fifty years ago are already completely forested. The landscape today is without doubt something of beauty, but the balance in the ecology has shifted.

Despite the speed at which the forest regenerates and the dilemmas over how land should be managed on this scale, you can still trace history in the forest. Recent customs were testified to by the remains of a fallen tree made famous for the fact that lovers could drive onto it in their cars. They would have been able to feel part of the forest whilst not having to muddy their shoes. 1950s postcards captured the moment and the ramp carved out for the wheels was still much in evidence. I had my own photograph taken, for it was hard to resist. Not far away the chocks were still visible in some of the trees where the pioneer loggers of the nineteenth century had made their way into the forest to fell the redwoods for lumber. What an extraordinary feat it must have been when whole communities moved in to work the forest by hand. They would have lived and breathed their environment, while doing damage that not even the forest fires were capable of.

Few of the very giant redwoods escaped the loggers. We visited the General Sherman, the biggest tree in terms of biomass still standing. It was hard to take in its scale, but when you wandered from the track you could feel the time in the trees. Deep, spongy litter lies soft underfoot, damp, still air is held amongst the trunks. There is an absolute still on the forest floor but high above, up where there are chinks of blue, the sigh of wind is caught in the tops.

The scale of the landscape in America has always inspired cultures. It is humbling and confronting and easy to lose a sense of scale and proportion. A log jam in a river may look like twigs in a stream when the twigs are in fact trees, the stream a river a whole valley wide. When you see the powers

wreaked by Mount St. Helens further up the west coast it is clear that we have very little control in the greater scheme of things. The forest there was literally snapped away from its roots and the trees still reveal the splay of the explosion radiating out from the epicentre. And when you are deep in the redwood forest, it is clear why we have a very real fear of the woods and a need to dominate our surroundings to remove the fear. There must be something primeval in all of us that makes us uncomfortable in the presence of such omnipotence.

As we moved further on to Yosemite, the landscape started to make itself felt as the geology pushed through the trees to form the iconic cliff faces that Ansel Adams made his own

78

in his photography. The strata lifted up where it had been forced and buckled, rocks snapped and stacked upon themselves. Vast flanks of stone rose sheer out of poplar-strewn shingle banks where the rivers broke through the valley. Water ran cold and reflective, light was caught on pale stone, stones folded, were worn and tumbled in scree where each piece was the size of a building.

High up in hanging valleys, there were remnants of meadows and as we moved higher still, the frost had already started to hang around in the shadows. The trees finally gave way to rock. This upland valley had been carved out by a vast glacier. Glacial erratics lay strewn like crumbs; dark pines emerged from shakes in the stone. It was here that we found the bristlecone pine, reputedly one of the oldest trees in the world. It was part of its environment and had been for two thousand years. The Native Americans, the settlers and the valleys that had filled with trees since John Muir had walked them were just a moment by comparison. And in that moment it was good to feel, to a degree, inconsequential.

## CHICAGO PRAIRIES

On my first visit, I must admit not warming to Chicago and as I made my way through the windy corridors between the buildings, I couldn't help but wonder what it must have been like for the first settlers to have carved this grid of concrete and towers into the Illinois prairie. Today, the city has detached itself almost entirely from the vast expanse of natural landscape that once lay around it. Skyscrapers, concrete and lawns that sprawl through the suburbs roll out from one front yard to the next. Beyond that is the monoculture of farmland and there is little room left for what gave Illinois its name – The Prairie State.

When I first visited Chicago in 1997, I came to visit the Wild Bunch to talk with them about conservation. At that time it was illegal to leave your front yard unmown, and their efforts to plant miniature prairies to break the relentless lawns of suburbia were anarchistic. This example of guerrilla gardening it seemed has had its influence, as ten years later I returned to the Millennium Park to see the Lurie Garden alongside the Jay Pritzker Pavilion concert venue designed by Frank Ghery. The Lurie Garden is a collaboration between Gustafson Guthrie Nicol Ltd, Robert Israel and Piet Oudolf, who used native American prairie plants in the garden planting. Though paradoxically the garden is the roof garden to an underground car park, it has a devoted following and has been responsible for a considerable shift in opinion around native American plants and their place in culture today. Roy Diblik, who runs the perennial nursery that supplied the plants was my guide and took me beyond the city to see a new movement that was gathering strength to recreate prairies on a bigger scale.

The vast prairies once covered 220,000 square miles, all the way from Canada to Texas, Indiana and Nebraska, and when the settlers arrived they were seen as being rich for cultivation. In just over fifty years in Illinois alone, the greater majority were swept aside to make way for the industry of farming. Today the original prairie only exists in slivers of land – the rocky places that can't be turned by the plough or the railroad embankments that haven't been sprayed out for ease of maintenance. Pointedly, and rather poetically, I thought, the pioneer cemeteries had also acted as an oasis to the plants that were swept away by the settlers.

It was from the seed gathered in these sanctuaries and overlooked places that a series of new reserves are being recolonised today. The movement was started in the early sixties by a growing number of volunteer environmentalists and nature lovers and is now responsible for several areas of recolonised prairie. I was shown one of the first restorations at the Morton Arboretum. It was a startlingly clear autumn day, cold and still, and we walked through the fringes of oak woodland and out into an open area of about twenty acres. My first impression, for I am used to grassland in Europe being waist height, was that it towered, with the grasses and eupatoriums standing well over shoulder height.

CHICAGO PRAIRIES

Showing its autumn colours, the young prairie struck a marked contrast to the artificial green of the mown lawns of the gardens that lay beyond. Once inside, the spent seed heads had taken on every shade of brown, fawn, silver and parchment white. In certain places there were hot cinnamon stems of rudbeckia and peppered darkly throughout, the coal-black seed heads and the grey-green of long gone baptisia. Prairie dropseed, *Sporobolus heterolepis*, a grass that has a sweet sugary perfume when flowering, formed low clearings where it had developed into a colony. Amongst it, in a combination that it would be impossible to better in a garden, were jagged eryngium or rattlesnake master and soot-black echinacea. Standing half as tall as me again was *Silphium laciniatum*, otherwise known as compass plant, because its foliage always aligns itself north/south. Its scalloped foliage had turned a leathery brown.

Later in the day, Roy and I met up with Tom Vanderpoel, a charismatic leader in the contemporary prairie movement. He took us to Flint Creek, a six-year-old project of some sixty-five acres. The land was purchased by Citizens for Conservation, a volunteer group who now own about four hundred acres. We took off along a tiny path gathering handfuls of seed, which he then scattered in a sweeping movement of his arm when the right moment came to redistribute them. He was reading the land and sowing the seed where he knew each species would have the best chance of thriving. As I followed I asked how you went about re-establishing an environment that had been erased well over a hundred years ago. 'The restorations are a combination of science and art, the larger your perspective, the greater your understanding.'

He went on to explain the intricacies of the grassland, operating on automatic pilot as he showered seed into areas that were ready for it; where the brome grass, the grass sown by the settlers for grazing, had been weakened enough by the other prairie plants. Set free and given the room to thrive again, the process of recolonising the natives is possible. Using the most vigorous species first and then inter-sowing weaker species like the prairie dropseed and the balloon gentian, it has been possible to create microclimates to suit a whole range of plants. In just six years two hundred and sixty species had been re-established on this site alone.

The restoration projects are funded partly by seed, which is collected by volunteers. Each site is sown according to the local conditions, which are often wildly removed from their original state, farmed and infertile, drained of the ground's natural resources, but the volunteers are keen for diversity so they undo the sterile farmland by breaking the land drains to create a range of conditions again. Traditionally, the Native American Indians burned sections to clear the thatch that builds up in time and eventually leads to the colonisation of trees. In these limited spaces, it is carried out today in controlled situations at the end of winter before growth starts. Tom said that they only burn the prairie in sections, to allow the wildlife that has flocked back room to escape the flames. 'Building the food chain is just a small part of this work.' And you have to question now, which is the natural state of things, the ring-fenced reserves or the sprawling monocultures of commerce?

CHICAGO PRAIRIES

## ANISH KAPOOR 'CLOUD GATE'

I loved the scale of Kapoor's *Marsyas* in the Turbine Hall at Tate Modern. The way that it seemed to have grown into the space and to be straining against its cramped, confined surroundings. *Cloud Gate* at the Millennium Park in Chicago offers in many ways a reverse principal, for its surface is like a magnet, bringing the world towards it in its reflective surface and creating its own space in the process.

Once again scale is key and the form holds its own against the monumental surroundings by capturing them in reflection. It appears like mercury or a bead of liquid that must have inspired the form, and the buildings, pavement, trees and sky are all captured and revealed a second time on its surface. Autumn foliage, passing clouds, people and animals are repeated and there is an air of intensity around it as a consequence. It has a mesmeric quality and a gravity, and yet, despite its size, it also has levity and its own energy, which animates this area of the park.

88

## COMMUNITY GARDENING

I first became aware of guerrilla gardening in the early 1990s when I was staying on the Lower East Side in Manhattan. In the empty lots where buildings had been demolished, groups of opportunistic gardeners had made it their mission to garden and green the city. Led by Liz Christy in 1973, the first people who took it upon themselves to garden in this makeshift manner called themselves the Green Guerrillas and they did their work by stealth and enterprise, cutting the chain link and scraping soil together amongst the rubble. The first garden they created in the Bowery area of New York still exists and is now called the Liz Christy Community Garden, protected today by the city's parks department. Such was the success and the good feeling created by the plant life that replaced the dereliction that Operation Green Thumb was founded, and in the time that a plot was vacant, these temporary gardens became official.

What I loved about the gardens was that they were a means of expression for the people who were gardening them. They were spontaneous, unpretentious and vibrant and they were focal points for the different strata of the local community. Each site was also completely different from the next and, although some had a cogent narrative that pulled the whole together, most were divided into small parcels of ground.

The closest parallel to gardening on common ground in the UK might be the British allotment, but the rules in Manhattan were different. The gardens were self-policed in terms of what you could grow there, one person coming to an agreement with the next as to whether the shade they had created was good for their neighbour's crops and so on. Consequently anything could happen and, in a strange way, these gardens bore more than a passing resemblance to the English cottage garden. Vegetables and herbs were entwined amongst the flowers and often the plots were ornamented and organised with assemblages of found objects that provided climbing frames for beans and morning glory, or makeshift divisions between the beds. A tiny garden pond, not much larger than a sink, surrounded by brightly coloured annuals might sit cheek by jowl with a brass

bedstead planted with runner beans and tomatoes while, on another plot, an oil drum brimmed with chillies and okra. The way the plots came together was also as multicultural as their gardeners. These were egalitarian spaces that had at their foundation the feel-good factor of growing.

Inspired by what I had seen, I became fascinated by the idea that anybody could garden if they decided they wanted to. It was also a revelation to me that you didn't always need a garden to do so, and these orphaned sites or places in which you might not expect to find a garden were often the most vital and life-enhancing precisely because of their context.

The Barge Gardens by Tower Bridge on the Thames in London are another fine example of gardening in the face of adversity. Here the community has made a series of floating gardens on the decks of the old industrial barges, which are now permanently moored and inhabited. It is a surreal experience to walk amongst them, each barge top contributing to the next so that the collective experience becomes a floating park. There is a makeshift quality about this floating garden too but the owners are proud of the oasis that they have created in the city and the gardens thrum with wildlife that would simply not exist if the barges were left unadorned. Once the walk that ran from the centre of London to Greenwich would have passed through water meadows, and Pepys' diaries bear vivid testimony that the country came right into the city. The barges capture something of the mood that might once have been on this very spot.

COMMUNITY GARDENING – RIVER THAMES

I was living in Bonnington Square in Vauxhall in the first half of the 1990s. It had been squatted during the 1980s and the community there had already begun to plant the pavements as part of a collective desire to soften the urban environment. My roof terrace was the first to take advantage of the eleven by sixteen foot flat roof over the Victorian extensions in our block but very soon it inspired a rash of people doing their own thing to take advantage of the views, the air and the chance to garden in unexpected circumstances. It led to my involvement with the next wave of greening the environment in the development of a park on the wasteland in the centre of the square.

The empty plot had been formed when seven houses were pushed into their cellars after bombing in the war, and in response to the threat that it might be developed, we formed a garden group to find ways to keep it as green space. One of the last GLC grants was obtained from a supportive councillor and a short-term lease from the council was granted to develop the wasteland as a park. We set about it as a group, pulling energy and experience together to make it into a garden. Evan English, a filmmaker who was the main force behind founding the group designed the lighting and salvaged a giant slip wheel that was being dismantled at the local marble works. A set builder welded it back together and garden days were set up to plant and then tend the garden. I teamed up with a New Zealand landscaper, Jimmy Fraser, to design the planting, which in the end was as eclectic and uninhibited as the inhabitants.

Over the years, the park has gone on from strength to strength and much of that is down to the good feeling that it has brought to the community. Locals care for the park on a day-to-day basis and invest in its future by keeping it in good condition. This is key to its success and the sense of ownership means that vandalism or theft has been kept to a minimum. It is a party destination, but people can be alone there too. It is a place to take the air and to get in touch with the seasons. And the rush of the traffic, which is not so very far away, is dampened by the foliage and by the feeling of sanctuary. The spirit of place has been caught and energised by the people who use and care for the garden. Their will to do so based upon the conviction that the gardens are life-enhancing and of value.

COMMUNITY GARDENING – BONNINGTON SQUARE

ROOF GARDEN – BONNINGTON SQUARE

As I travelled further afield, I started to take note. I found people tending less than a few feet in alleyways in Tokyo; one little garden running into the next in a chain reaction that eventually greened the street. Five flights above a tyre shop, in another part of the city, I encountered a man who had moved there from the countryside. His parents had been farmers. He had wanted to bring something of that with him and had soiled up the top floor of the building to plant a fully functioning orchard, which burst over the walls high above the street. There were grapefruit, lemons, pomegranates and kiwi fruit, and we drank plum wine, which was a product of his efforts. Another building in central Tokyo had been completely covered in hundreds of bonsai that were strapped to a superstructure the owner had built over the framework of his house. We clambered along boards and across the roof to look at his specimens. He was an obsessive and the collection illustrated a somewhat out-of-control passion.

COMMUNITY GARDENING –TOKYO

COMMUNITY GARDENING – TOKYO

## JAPANESE GARDENS

Instinctively, I knew that I should have an affinity with Japanese gardens as their roots lie in the appreciation of landscape, but until going there for myself the usual points of contact had left me cold. Japanese gardens that I visited in Europe were a disappointment. It was clear that the philosophy of how they were maintained did not travel well. There is no denying the beauty of the images in books but there was something static and restricted in what I saw. The compositions felt cold and lifeless. I wanted to get inside the gardens to feel them for myself and to understand how they aimed to capture the spirit of landscape. I wanted to witness the animistic approach to things and to see if this was what was missing in the frozen image.

I had no idea, until going there myself for the first time in 1997, how influential the real thing would be. The gardens were a surprise for they are far more removed from the 'natural world' than I had ever imagined they could be. The compositions are a stylised vision of landscape in which the elements have been meticulously edited and juxtaposed, and they provide the setting in which to connect to it in the mind. This is through suggestion as much as it is imagery, and the art of reduction – the importance of editing back to the bare essentials – is paramount to the detail in the greater picture being revealed. My own work has shifted as a result, through the removal of the extraneous and the realisation that less can reveal more.

I was shown several gardens by Shunmyo Masuno, a Zen Buddhist monk who also practises as a garden designer. His work was modern and hard edged in places and the garden at the Canadian Embassy was interesting for the paring back to not much more than stone. That said, he managed to bring something elemental to his pieces and having a guide was a huge advantage as I was taught how to look and what to look out for. I was taken behind the scenes and allowed to see the gardens at dawn and dusk, when they are at their most peaceful and the light is at its best. I was also introduced to Mr Kubo, the designer of Kengo In, a contemporary temple garden.

He had come to design gardens from another discipline as a painter of gardens and it was prudent to meet him early on. He had learned about the components that were part of both garden painting and garden making, but his need to work in 3D had only been fulfilled when he could also work with physical space. He had learned about the great landscape

painters and how the borrowed view was intrinsic and enabling, taking the eye beyond the confines of the garden to extend its boundaries. He recognised the importance of informality, how nature rarely drew a straight line and how the eye preferred asymmetry. The art form of garden making was part of this education.

Through learning the traditional route, he was able to kick against it when he recreated himself as a garden designer, and Kengo In is stylised and surprisingly contemporary in feel. Rounded forms of clipped azalea-like, river-washed boulders were broken by the vertical of conifers clipped into stylised forms to edit the hill in the background. When questioned, both he and Shunmyo Masuno admitted to not having used nature itself as the inspiration for the gardens that they created. The art of garden making, it seemed, was something that was learned as a language, by studying what had come before and not going to source for inspiration.

Perhaps this is the reason that the gardens that I visited were without exception about control. Every component was connected to the next so that each and every element within the composition had been considered. The art of reduction had been taken to extremes in the gravel garden at Ryoan-ji, the references to landscape stylised within the composition. Water was replaced with gravel, a backdrop of hills revealed in the mud wall that framed the space. Plants were excluded from the frame.

Shunmyo and I were lucky enough to visit very early in the morning before the crowds descended. The approach to the temple is up a wide set of steps that were timeworn and imperfect, overhung with maples and encrusted with moss. Imperfection is important in its place, and age and patina are revered. This is illustrated in the mud wall that frames the garden which has been given the title of a national treasure and is marked by the process of ageing; the oils that had been used to bind the mud having distilled themselves into a backdrop that is a landscape in itself.

Shunmyo asked me if I wanted to talk or sit in silence so we sat on the wooden platform that overlooked the garden and contemplated the stones and gravel. It was evident that the control is an expression of humility and it felt inappropriate to try to put your thoughts to words. As it is impossible to see a panorama within your field of vision, you are unable to see all the stones at once and your mind's eye had to make the connections. There are fifteen stones in total and from certain angles it is possible to see all but one. It is said that only through enlightenment is the fifteenth revealed. The minimalism within the enclosure allows your mind to settle and before long you start to notice detail; the lichens on the stones and the particular angles at which they had been juxtaposed. After a time, you can feel the energy of the stones, how they push from the gravel or tilt to reveal a particular weight. The monks had set the stones there in the fifteenth century, and the power in their juxtaposition is just as powerful, if not more so today, for having survived the evolution of the culture around them.

The moss garden of Saiho-ji Temple, was another garden that provoked a profound connection to the elements within it. The introduction to the way of being in the garden was aided by a ritual that you have to go through before you are allowed to enter. We had to sit on the floor in the temple and those who could chanted with the monks, those who could not traced over a prayer with pen and ink. It was only after you have completed the task that you are allowed to enter the garden, and by this time you have been put into quite another frame of mind by being part of the ritual.

Saiho-ji is a landscape that has evolved over time and though there is naturalism here there is none of the disorder that you might find in a natural landscape. The islands on the lake were apparently covered with silver sand in the fourteenth century. The moss that covers them now came later, over a hundred years ago, during the Meiji era when the monastery lacked sufficient funds for upkeep.

You are invited to move around and through the garden on a series of tiny paths and stepping stones that are configured to slow your movement. By being forced to concentrate on your footfall, you are encouraged to take in your surroundings with a new intensity, one that allows you to see that the carpet of moss is in fact a garden of many different mosses, each with their own green and particular habit. You might notice that a single camellia flower, crimson against the green of a fallen leaf is left there as contrast. With such evident attention to detail, I was not surprised to discover that it can take up to twenty-five years to qualify as a Japanese gardener. You only look up when you pause at a destination or a larger stone where you can rest both feet comfortably and do not need to concentrate on picking your journey forward. You begin to notice the shadow patterns shifting on the ground, the rise of fish breaking the water in the milky lake that you are circling. You notice too that your ear selects the sounds that it wants to hear and that you have edited out the sound of Kyoto beyond the garden fence.

As you move away from the lake, the experience unfolds like a well-paced story and there before you is the finale, a dry cascade moving up and away from the lake into a gentle incline. There is no water in this cascade but your senses are now attuned and you can feel the rush between the boulders, the still in the flats and the push from side to side as the energy of the imagined water is deflected along its course. It is a timeless and powerful composition, as robust as it is delicate. You have been part of the journey and consumed in the moment and your senses have been teased very gently so that your antennae are newly receptive to the subtleties of the natural world.

JAPANESE GARDENS

## HOKKAIDO FOREST HOUSE

I have been working in Hokkaido for several seasons with a landscape designer called Fumiaki Takano. Hokkaido is the northernmost island of Japan and life is very different from the mainland, with snowbound winters and a sparsely distributed rural population. The landscape was colonised for agriculture just last century and today most of the valleys have been ploughed and many of the mountainsides taken for forestry. By including me in the Millennium Forest Project, Takano saw the opportunity of revealing something new through eyes that were unfamiliar to Japanese ways. This works both ways and through working with him, I have seen sides of Japan that I would never have encountered otherwise. He took me to a tiny bar in Shinjuku, up the backstairs of a street I will never find again. It was no larger than a boxroom and lined with a film buff's posters of French cinema from the sixties. The owner had lived in Paris and was there at a miniature bar. She was impossible to age, yet from another era entirely. On another occasion we visited a backstreet full of tented restaurants, in an industrial town where the temperatures fall to below thirty-five degrees centigrade in the winter, each with its own cuisine where you huddle with strangers around the cook in the centre.

Then there were the whisky bars with the hostess service of modern day geisha, and the hot spring deep in the forest, no more than a hole in the snow by a racing stream. We drank Sapporo beer, with one hand above the steaming water to hold the can in the icy temperatures, and waited for the moon to illuminate the birch woods in the snow. My hair froze to icicles and my clothes had to be broken open where I had rolled them tightly into a ball. I have rarely felt so alive in that rush to get back into them, my body steaming and skin tingling.

One spring visit, we had spent three very intensive days in design discussion on site, trying to get to grips with how best to plant a new perennial garden so that it felt closely connected to the mood of the forest. It had been hard work and as we left for the airport, my head was spinning with the risks that we would have to take to make this scheme viable in this extreme climate. We had been weaving through the fields of asparagus and beans that are grown in the black soil along the base of the mountains for a while, before we pulled off onto a little track that took us immediately into woodland. Takano usually pulls a surprise and this was it. A small house sat on the edge of a clearing. Tin outer doors to protect it from

the plunging temperatures and snow in winter, sliding inner doors to allow free air movement in the summer. The man who lived there, it was explained, was a tailor in the local town. He had bought twenty acres of woodland fifteen years beforehand with the intention of this being a retreat, and in that time he had developed something quite remarkable. We had come here to see how he was tending the forest.

He was profoundly shy, but we were invited into the house, first into a little antechamber, where there were bricks laid on a dirt floor. There was a woodpile here, an iron stove and outdoor boots and coats. A miniature Zen garden of ferns and moss sat on the threshold between inside and out, and from there you stepped up in stockinged feet onto the polished wood of the main room. It was dim as there were no electrics and the flare from the open window at the far end of the

room demanded that you slow until your eyes adjusted. In the far corner there was a raised area with sliding screens to enclose the bed, in the centre of the room a fire pit around which you sat on cushions to cook and eat. A chain hanging from the rafters suspended a cast-iron pot from a hook of twisted wood.

It was spellbinding to move out through the sliding windows onto the platform that projected into the tiny valley and I felt choked with the magic of it. The forest and the life which it held was there to touch, pushing itself up to the very edge of the house. The reason to be there was to be part of the forest. The light was soft, if not gloomy under the weight of trees, but there was the sound of water rushing below in the undergrowth. Upstream and just far enough away from the house to make it a journey was a low-slung building, heavy under thatch but hovering on stilts as it straddled a spring that joined the stream. Just beyond, there was a tree house set up in the canopy.

We picked our way through a tiny mud-trodden path to the first of the buildings. A cup by the springhead sat on a rock to take the water on the way there. He had hand crafted the building from the forest. Twisted oak limbs formed the supports, planks that had been cut from the fellings made to clear space for the house, formed the floor. Thatch from the reeds at the edge of the clearing were fashioned into a flaring sculptural roof. We de-booted once again to sit on the tatami mat underneath it and take in the water rushing under the giant foliage of the skunk cabbages and kingcups that cushioned the platform.

It was here that Takano explained how our host had been 'gardening' his forest. Oak lumber was removed in the early part of the twentieth century and with that came the first unsettling of the ecology. Light falling to the forest floor caused the sasa to proliferate, to the point where the waist high bamboo established a new status quo. The monoculture erased the diversity, which had evolved there over millennia. By repeatedly cutting the bamboo, forcing it to weaken and retreat, our host revealed in its wake a forest floor, which miraculously regenerated, from a seed bank left in the soil. Over the years this quiet man had been tending his twenty acres for diversity by steering the ecology.

We wandered the site, which in effect was his garden. He reached to the heads of the giant angelica that were taking over in one area to snap their flowers to prevent them from seeding. He gathered seed from the sweep of trillium that had colonised one side of the little ravine and broadcast it where he knew the lightness of the thalictrum in another would provide the perfect shelter for a new colony. There was no digging, no conventional gardening practice happening here. By reading the balance between the plants in the forest and through a process of editing, he had heightened the natural ecology to a point that could only be described as breathtaking. This was a light touch with a broad vision, a vision that was about being part of the environment rather than dominating it. There were carefully chosen stopping points along the way. A log to focus a viewpoint and to act as a makeshift bench, and down by the stream a giant cauldron, where he lit a fire to heat water in which to bathe.

Later, when we were making our way back to the car, we climbed the tree house to gain the bird's eye view that was the contrast to being in the understorey. The notched trunk that formed the steps up into the canopy had as its handrail a twisted vine, and the two-seater platform was orientated towards the view out into the little valley. It was no coincidence that he had chosen to place the hide amongst the katsura trees, which in the drizzle were filling the still air with the smell of burned sugar. It was with great reluctance that I got back into the car, but on the way to the airport, it was clear that in my short visit there, time had been slowed. In the most gentle way, the senses had been teased and the mind provoked into thinking that the light touch was the right way or at least one way to enter the here and now and to be truly part of a place.

Tragically, I returned the following year to find the house had been razed to the ground in a fire, but the tailor was already crafting a new building made from the local materials up in the trees behind it. He was making this single-handedly and the seedlings from the surrounding forest were already germinating amongst the ashes.

HOKKAIDO FOREST HOUSE

**EDWINA'S RETREAT**

Buildings that set out to capture something of their surroundings and do so successfully are rare. My friend and fellow landscape designer, Edwina von Gal, lives in a wonderful example near East Hampton in the States. The previous owner, the architect Hamilton Smith (partner in the Marcel Breuer office) completed the building in 1974. It is quietly powerful. Strong and modernist in outline, but modestly sized, it is an elegant structure and, since it is made from wood, it sits just so in the trees and amongst the reeds that fan out into the bay. The timber has silvered over time so the building reads as part of the landscape. It has become part of both the wood behind and the marsh, nestling into the low, salty woodland of oak and wild cherry that runs along the coast.

The genius of the building is that it is raised up on stilts to allow it to be as close as possible to the shifting marshland. The house feels like a hide from which one can observe nature at close quarters.

You approach the house through the trees and, when you first set eyes upon it, it appears to float between land and marsh. Edwina has thinned the wood at its margins to allow the house to occupy a breathing space of switch grass, wild asters and milkweed, and the full range of habitats is encouraged to blur the boundaries between the forest and the wetland beyond. The first glimpse of the bay is framed by this clearing and focused through and underneath the house so there is a sense of expectation that builds as you ascend the steps to the house.

Walking up the wooden stairs, you leave the woodland behind and the full glory of the bay is revealed from windows that run the entire length of the open-plan interior. A door opens out from the kitchen area onto a terrace and another deck that extends from the main bedroom. From these elevated platforms you can watch the wildlife in the marsh as the light passes across it and the tide rises and falls. The seasons are mapped out in the environment. I have seasonal emails from Edwina describing the ice creaking all around her in the frozen bay or reports of the arrival of the migratory birds that come and go.

The habitat is absolutely key to this house and it provides all the distraction that is needed. The drive and parking area are seeded with wild plants so that they register as nothing more than a track and clearing. The spaces under the building are unadorned brick terraces that can cope with the ebb and flow of the tidal water. Simple furniture animates these spaces and the house provides shade here in the heat of the summer. There is no garden to speak of. The wild plants at the foot of the building are maintained for diversity and the trees are carefully edited so that those with the most character remain as points of interest. A fenced off plot used to grow fruit, vegetables and flowers for the house is set back in a clearing in the woods so that it does not distract.

The property is connected to the environment around it by nothing more than a series of well-worn paths that lead out into the marsh like animal tracks. From the terraces above, you can see that the marsh has been managed with a series of formal drainage channels that divide the wetland. On marshy ground, a series of boardwalks focuses your journey to a jetty that projects out over open water. By the time you reach this point, you are quite some way from the house, which has now dropped back into the trees. You can take a canoe trip out into the bay from here, paddling along the margins of reed where the wildlife is hiding. At no point does the building jar or feel out of place, yet it gives the little promontory on which it sits a focal point. In my mind it is an exemplar of a building that is light on the land and if it were to be removed at any point in the future, there would be little sign that it had ever existed.

## JP'S CABIN

An old friend, JP recently acquired a five-acre plot in Connecticut. He sent me pictures of a Native American axe head he found on the ground and endless images of the land to entice me to visit. This is not the Connecticut experience that immediately comes to mind. There are no picket fences or emerald-green lawns framing clapboard and verandahs. This is my ideal property: a humble building with an outlying barn, which is set in an environment that invites nature right up to the front door. There is no garden to speak of, save the pumpkin patch where Native American corn and essentials are grown for the kitchen, but the land is as rich an experience as you could ever wish for.

The log cabin was originally built in the early nineteenth century and the previous owner, John McCreedy who was a naturalist, had found it whilst paragliding over a place called Pigeon Roost in North Carolina. At the time he was making a film about birds on the wing and had befriended a hawk that flew with him over considerable distances. The cabin, one room with a loft above it, made from tulip tree and chestnut, had been spied from the air and after dismantling it log by log, he moved it to his plot in Connecticut. Newspapers were rare when the wood for the cabin was felled from the forest and one copy would often be passed around a whole settlement, so it was the height of luxury to be able to paper the inside of your cabin in newsprint. Fragments of the paper are still there on the inside today.

McCreedy had kept a condor in a special cage and flew it in the valley above the property. In the concrete floor of the barn, there is a giant footprint of the bird. In the time he occupied the plot he had made it his mission to build up the ecology and he managed the land with an ecologist's head on his shoulders.

That brought aesthetic challenges, and certain dying trees were singled out so that they provided the birds with perches and clear views from empty branches. Some of the branches had been cut, but left hanging in the trees, so that they provided a rich array of opportunity for the different habits of the birds that came to settle there. In a grove of sugar maples several giant trunks had been ring barked so that they could become home to the woodpecker colony that he was studying. The hollow sound of the peckers reverberated around the valley.

The cabin became the hide or the observatory to the land around it and the environment came right up to the front porch. An old polaroid from the mid-eighties showed the clearing around the cabin as not much more than meadow, but over time, and to provide touch-down places for the birds, he had allowed it to be colonised by shrubs. Wild cornus and various natives selected for their droops and berries had formed islands in the meadow and nature was rapidly reclaiming the land and reverting to its natural state. JP had to be mindful of this when he took the property on because woodland is the natural state and the way the land wants to go. To retain diversity of habitat it is necessary to steer the land. The meadows and the seedling trees and shrubs amongst them have to be edited, so they are selectively cleared in the winter to break the natural succession.

The meadows provide the calm in the landscape, the clearings that allow all its roughness to sit well. Little tracks have been cut into the grass in the summer so that you can make your way from point to point and these help to further the feeling that all is not lost to the apparent wilderness. A clearing made directly around the building feels like a primal requirement and there is just enough here to prevent it from being overwhelmed. The front stoop floats out into this clearing and makes the link between inside and out.

The building is no more than it needs to be, with one room downstairs and a ladder to a platform in the roof. A chimney made from boulders forms the greater part of one gable end, and tin has replaced the original shingles. There is a pared-down aesthetic that allows you to focus on the way in which the logs have been set together to make the walls. There is an honesty of material that JP has carefully added to. A zig-zag ceiling set between the beams reflects the light from the modest windows. A new window in the roof frames the hill in the distance. The darkness of the interior is embraced. There is a simple wood-burning stove to heat the space and there are plans to replace the traditional chinking of mud paste between the beams.

Outside, in a room that has been forged from part of the barn, insect screens are set in the original openings to allow you to be as close to the environment as possible. Sleeping here in the summer, you feel as if you are outside, with the air moving over you and the sound of nature all around.

## CHERRY WOOD PROJECT

Not far outside Bath, deep in the fold of a wooded valley, is the Cherry Wood Project. Tim Gatfield is the founder of this small but significant concern. Formerly an army man he went on to become a cabinet maker, and has now developed his skills to live a new life on the land, where he lives very simply, working the woods to provide for himself and others. In addition to managing the woodland he runs a number of courses, where it is possible to live alongside him and learn a range of skills essential to living a sustainable existence on the land. His courses are a means of passing on skills (many of which are being lost) and a way of living that has a very low impact on the land.

'Sustainability' is a word that I am very careful about using. Buzzwords quickly lose their true meaning, to be held hostage to political and economic convenience. But here this ethos is lived out in a truly responsible manner. Everything is put to good use and the primary aim is to respect the natural balance. Tim only takes from the land what the land can afford to give. You feel that if he upped and moved camp nothing would remain that wouldn't rot back into the ground in a short space of time.

Living outside and being in touch with the elements is the key to being in these woods and the main residence is a yurt in a clearing up the hillside. It sits on a platform amongst foliage with a small hut alongside that is the kitchen. Inside the yurt is as snug as any home needs to be. There is also an area to eat and a shower hut with water heated by a wood-burning boiler made from an old gas canister. The surrounding woods provide fuel for the wood burner and also the means for Tim to make his own kitchen utensils, furniture and even the shingles for the wood-storing barn he is building. A small windmill, which he acknowledges works better when the leaves are off the trees, provides power for light.

Tim runs green woodworking courses, with all the furniture being made of timber from the woods. The teaching building was erected with course members who came to learn how to make a building from scratch. It is an A-frame pole building made from triangulated chestnut poles, and weatherproofed with a simple tarpaulin. A second A-frame building provides a communal kitchen where course members cook and eat together around a wood-fired earth oven, which has a reputation for very good pizza. Most of the students leave a handmade spoon to add to the utensils. These are made from sycamore, and the most accomplished are as translucent as fine bone china when held up to the light. Nearby is a second shower hut for guests and a long-drop toilet cantilevered off

an incline. The long-drop is covered in handmade shingles and the far side of the building is open to the elements, giving the two side-by-side seats inside a view out into the tree canopy.

The equipment for woodworking is also made on site. Carpentry benches on which to split shingles and, for the more ambitious, pole lathes to turn legs for a stool, a chair or a high-backed carver. Tim also teaches coppicing and hurdle-making, charcoal-burning, bow and arrow-making and bark-weaving, as well as passing on his bushcraft knowledge. When areas of the wood are coppiced, heavy horses are used to haul the timber up the steep embankments, because of their light impact on the land. Following coppice clearance, six-foot high 'dead hedges' made from stacks of brushwood are carefully constructed around the newly coppiced areas to keep out deer.

In another area that is also protected with fencing, Tim has planted a small orchard of fruit trees. He is practising permaculture here and, under the apples and plums, are raspberries and wild strawberries.

Though the Cherry Wood is in every way aspirational, it is not 'the good life' as you might expect it could be. The life here is real and committed. Tim has created an environment where people who might be out of touch with nature or have not experienced it close to, can engage with it in a very practical way. They can take something of their experience away with them in the form of something they have made or a new awareness about the importance of treading lightly.

**WISTMAN'S WOOD**

A powerful granite gateway channels the path over the time-worn stones that lead to Wistman's Wood. We make our way across the moor over an exposed ground of winter-bleached grass and just-flowering gorse. Methern Brook, which feeds the West Dart River, runs nearby and is little more than a fast-moving stream amplified through the strew of boulders in the valley bottom. It provides what little sound there is on this still afternoon in February.

Wistman's Wood is set in the heart of Dartmoor on a west-facing slope where the ground folds to create a little shelter. The sun was about to dip below the opposite hill as we approached the oaks. According to a local history book that I picked up later that evening they 'had survived amongst a clatter of granite boulders because it was hard to extract the timber'. I also learned that the Druids, with their animistic belief system had once turned the whole of Dartmoor into a temple, and that Wistman's Wood was a spot where they regularly gathered. Over the years the name has been distorted and is thought to derive from Wiseman's woods.

The wood is not large and is made to feel that much more intimate by the contrasting ruggedness of the surrounding moor. An introduction of several oaks nestling in a satellite of boulders close by have formed a perfectly balanced colony, a miniature version of what lies beyond, with each branch extending no further than the company of the group allows.

On entering the wood and leaving the exposure of the moor behind, you are immediately absorbed into the mood of the place and it is a powerful reminder that there is something primal and safe in shelter. It is impossible to move freely due to the boulders, and your impeded movement makes each step something that has to be slow and considered. The first sensation is one of absolute quiet, every stone muffled by a thick coating of moss. The moss also unifies everything within the interior, which in marked contrast to the colour-drained moor, is a vivid, emerald green. The soft

muffling covers every surface and makes a union between wood and stone. Bright where it catches the low rays of the sun and dark in the shade, it provides a home for ferns and wood sedge that have taken to the branches. The place feels primitive and weighty with time.

My friend Hannah and I part to experience the place on our own, because it feels inappropriate to talk. It is surprising then to find that amongst the rocks, are other people who have been drawn there too. Each is contained in their own space, silent or stilled by the quiet, soaking up the ambience, to commune with the atmosphere of the place. It is melancholy and profound. It is the moss garden in Saiho-ji untended. It is a garden of its own making but it demands just as much respect. We stay until the sun dips below the hill and move away from the encroaching shadows to the high ground above to take in the last of the light.

On the hill above the wood is what at first sight I presume to be a man-made dry-stone wall, but as we come near, the scale of the tor shifts. The stones magnify as we move towards them and we become smaller. They tower as we stand at their base with our heads tilted back. I make my way up to the top, clambering from level to level. The stone that forms the table to the highest stack has a tear-shaped depression in its surface that reflects the sky. Although I am yet to read that the moor has been an altar to nature, you can't help but make that connection on your own. It is a place with a spellbinding gravity.

128

WISTMAN'S WOOD

130

## NEW ZEALAND

In 2005, I met up with an old friend, Sarah. She had moved back to New Zealand from the UK and headed south to her roots. I met her in Dunedin and we packed a tent and hired a car to make a road trip across the South Island. It took two days to make our way from coast to coast.

This was my second time in the country but I had remained in the North Island on my first. I have clear memories flying in over the black beaches where toi toi grass had colonised the dunes and the cartwheels of tree fern animated thick, dark bush. It was temperate there by comparison to the South Island, the winters mild and wet and the summers benign save the intensity of the sun. To an Englishman, the intensity of the sun is alarming and you can feel it boring into your skin, but the quality of the light is electric and throws the landscape under a magnifying glass.

132

It was the landscape that I had come to see and this was the first time that I had been to a land mass with such a small population. With just over a million inhabitants, confined mostly to the cities in the drier areas of the north and east of the island, there are vast tracts of land that remain untouched, and as we moved away from the city and the clutch of suburbs that cling to it, civilisation soon began to fall away. Green pasture and the animals that graze it are European introductions and they feel at odds and alien here. The fields are staggeringly intense under the scrutiny of the New Zealand light and very quickly you start to feel that there is something surreal in the juxtaposition of the native ground and legacy of the settlers.

There are only a handful of metalled roads that bisect the South Island, and you know that you will find yourself rapidly isolated if you take the dirt tracks. It was not long into the journey west that the influence of man gave way to the rise of the tussock lands and, if you take one of the tracks out to the hill stations, you are soon engulfed by the silence of remoteness. The tussock lands have a singularity about them, their rolling contours capturing the wind in the coppery grass that moves over them. Witnessing an element that goes largely unseen revealed in the vegetation is hypnotic; a ripple caught around you moving out and away and rolling up the hillsides like a choppy sea. The tawniness of the grasslands is turned up a notch in the low, golden light of the evening.

NEW ZEALAND

The hills begin to cluster more tightly until you are herded into the Haast Pass, the cut into the mountains that run the length of the west coast. The climate changes too, the rain shadow of the tussock lands giving way to wetter ground and deep, inky bush. Tree ferns dripping with lichens and moss hang from the cliff faces and waterfalls crash through the impenetrable growth as the sides of the pass rise above you. It is a claustrophobic two to three hours before the land opens out again and the valleys that greet you are laced in their bottoms with braided rivers. Monochrome shingle embankments several miles wide are delicately covered with water that foams white in places and swells a milky grey where it is quiet.

We camped up beside one of these rivers on the edge of a moss and fern encrusted forest. As the light fell, the milky water in the river became more luminous and the twisted wood behind us blackened. It was here that I saw the Southern Lights rising up behind the mountain in what I first mistook to be searchlights. We knew this could not be the case because we were almost as far south as you could get and this was slowly confirmed by

the enormity of the experience. The aurora australis is almost impossible to describe, but its magnitude is bigger and more eclipsing than anything I have ever been part of. I felt entirely humbled by it as the illuminations pulsed and rippled across a clear sky. We sat for more than two hours with our necks craned, being eaten by mosquitoes that sensed our distraction.

The force of nature on the west coast is at points alarming and the next day's events further emphasised how small the environment can make you feel. We drove on to an outpost called Jackson making our way south and parallel to the mountains. It was a single-track road which had been driven across a morass that lay in an elongated and extensive basin. The excess of inky black water running off higher ground was trapped by the geography and the tiny settlement clung to the full stop as the mountains swung down to the sea and terminated the swamp. A small cluster of houses hunkering into the bush and looking out to sea held the end of the road.

Though no one was to be seen, there was a caravan parked up, obviously going nowhere, in it we had the best fish and chips that I have ever eaten. The walls were lined with photographs of little boats that were trying to make their way in and out of the bay. They were curled and wrapped in the waves and it was here that we learned about the first settlers who had arrived there directly from Europe. They had landed in the tiny bay with great difficulty only to find that once on shore they were landlocked by the mountain and the morass. They persevered for several decades until they had to quit. We visited the burial ground wrapped with vine and undergrowth, up behind the houses.

We headed north later that day, parking the car in the bush and wading through a river with our tent to get to the beach that lay through the undergrowth. It was several miles

long and we could see the mountains descending directly into the ocean in the far off distance where it ended. Arcs of water pulsed from them in waterfalls that fell directly into the sea. There was not a man in sight and a massive knit of silvered tree trunks and driftwood was piled high in the dunes where it had been deposited by storms. Black rocks pushed from the water and we saw dolphins.

In the lagoons that were held back by the dunes a series of outcrops had been colonised by a layering of plants, one strata of vegetation stacked upon the other and interdependent. This was an environment that had remained unaltered by man, untouched and as fragile as it was strong. This was a primitive landscape, a rare and potent thing and one that put me firmly in my place in the order of things.

## PANTHEON

When I first visited Rome, I remember quite clearly the feeling of being removed from the experience. It was as if I were moving through a film set, with Corinthian columns strewn at the side of the pavement. The very acanthus that decorated them were the weeds into which they had fallen and the buildings were stacked on top of each other, modern day flats built into and upon the very remains of another civilisation.

I was staying with clients who lived in the heart of Trastevere and as I returned each spring and autumn, I took time to wander the streets and to try and be part of the experience rather than feel like an outsider looking in. I stumbled across the Forum, which was just a short walk over the river on my way to the Colosseum and as I grew more confident, I allowed myself the luxury of getting lost in the labyrinth. It did not help my filmic sense of detachment that I came upon the Fontana di Trevi so suddenly late one night. There was heat from the day still caught in the tight network of streets, but the fountain was roaring and cool and every bit as powerful as my memory of *La Dolce Vita*.

It must have been on my third or fourth trip that I started to feel less overwhelmed, and the abundance of riches and the city began to make sense. I had become more accustomed to the beauty in the dereliction and the patina of the generations, but it was the Pantheon that finally made the connection for me. The Pantheon was built in 126 AD by Emperor Hadrian, a cosmopolitan ruler who travelled widely in the East and was a great admirer of Greek culture. He built it as a temple to all the gods and, where many buildings were destroyed by later generations, it was saved as a structure because it was later consecrated as a catholic church.

142

Nothing had prepared me for the magnitude and weight of this building and I approached it side-on at first so that it was only revealed in part. From this angle, it appeared shoehorned into the city that has evolved around it and I remember wondering later if Anish Kapoor had felt this same feeling of volume and constriction when he designed *Marsyas* for the Turbine Hall at Tate Modern.

As you circled the narrow street that wraps around its backside, the stacked ruins of another building hunch against the dome and obscure the skyline when you look up. Swinging around to the square at the front, that Corinthian addition to the entrance is extraordinary in that it feels like an entirely separate formality, adhered to the front, yet undoubtedly fused to the dome of the original structure. This dome, with a diameter of one hundred and forty-two feet would fit exactly into a box of those proportions, which is perhaps why the formal frontage makes sense when you retrain your eye and allow the two structures to work as one.

It was raining the day I visited and the streets were virtually empty. I passed through the columns and the immense doors, which opened into the gloom. The dome within was empty, and there was a hush save the hiss as a column of rain passing through the oculus high above hit the marble floor. I followed the column of light-filled water with my eyes and imagined it connected to the clouds high above the city and then on and beyond that. I approached and stood by the pool of water that was channelled through slits in the shining marble floor into an underground drain. The mass of the dome was dark and heavy, the only source of light the window to the sky. The concept of the building, its simplicity and the way it made me feel connected to the heavens is potent and unforgettable.

PANTHEON

## JAMES TURRELL 'DEER SHELTER'

It was impossible to capture the Turrell light sculptures that I saw exhibited in the underground galleries at the Yorkshire Sculpture Park on camera, but they were completely sensual and have stayed with me. Upon entering a pitch-dark room, visitors were told rather enigmatically by the steward that they were free to reach out and 'touch the light'. At first, with nothing to provide the safety of an anchor point, the temptation was to feel my way towards the walls, but I had faith and stepped into the darkness and waited. The orientation became clearer as my eyes adjusted. Not immediately, but soon, a rectangle of violet light very slowly appeared. At first I wasn't sure that it was really there and wondered if the intensity of the light was being manipulated. However, I gradually became aware of my own physical reaction; the process of my senses recalibrating themselves. It felt as though time had been slowed in these minutes and that my senses were reaching out and straining to recapture their familiar connection with the world. I made myself relax, happy to be suspended.

Once I was sure of where I was, my next reaction was to try to capture the light, even though I knew this was a sensory impossibility. One by one, visitors moved towards the wall from which the light emanated to try and understand the illusion, to touch its softness and to understand its source. I felt on the edge of the real world. Somewhere unfamiliar.

The *Deer Shelter* is Turrell's permanent 'Skyspace' installation at the sculpture park. It sits within an eighteenth-century deer shelter dug into the side of the hill, which was originally built to provide winter respite for the park's deer. Once you enter the building you are sealed off from the outside world and directed to the inner chamber, a square stone room with a simple sloping seat, which encourages you to recline, look up and focus on the ceiling. The punctured ceiling reveals the framed view of the sky. It is an exercise in framing, concentration and focus and a means of connecting you with the 'heavens' much as you are in the Pantheon in Rome.

Again, I had to adjust to the light, but this time it was to the concentration that came with brightness. The sky became surreal, white at first, then colour as my eyes settled. The clouds that moved across the frame were unexpected since you couldn't see them coming, and they were brought closer by the focus of the aperture. The flit of birds was that much faster for only seeing a tiny fragment of their passing. It was a blue, cold day when I was there and once again the experience focused the senses to slow time and push distraction aside. I would like to be there before dawn to see the night sky shift to day and to see it at dusk to experience the draining of light, the shifting colour made all the more intense for its abstraction.

JAMES TURRELL *DEER SHELTER*

### RICHARD SERRA 'SIDEWINDER'

I was taken to see this Richard Serra sculpture on a trip to the East Coast of the States. It straddled the front lawns of a private garden, dividing it twice with two blades of continuous Cor-Ten steel, forming a pair, but never being truly parallel.

It had been a hot day and, as we entered the sculpture, the temperature immediately changed. It had its own climate and atmosphere. The steel blade that faced the sun radiated heat, which hung in the still air within, while the blade that faced the shade of the lawn was cool. We leaned on each to feel the difference and moved through the pockets of cool and warm air that mixed within the enclosure.

The walls invited us to take a journey through the slice that had been taken from the lawn. The width of the sky was constrained by the walls above us, and appeared to be bluer for this concentration. At points the opening narrowed where the battered sides leaned towards each other; at others the walls flared to let in more light and the abstract shadow patterns of the surrounding trees.

Emerging into the real world I was struck by how instantly my awareness of reality had been heightened and intensified by this immersive experience.

## MEMORIAL

I do not believe in an afterlife and maybe because of that, I find the need to make our mark a fascinating one. In their attempt to hold back time, or to mark a time, an event or a life, the memorial often emphasises the very transience of that moment. Although most memorials are designed for contemplation, in that they are intended to capture a certain mood that enables retrospection, the atmosphere that builds there often generates its own gravity. A lovers' tree that is scarred with inscriptions or a cemetery where a memorial wisteria eclipses the graves it was intended to commemorate.

Among the most touching memorials were the makeshift graves I found in Jackson in the very south of the South Island, New Zealand. Settlers had alighted there into a treacherous bay only to be held back by morass and mountain. The graves had been overgrown by the very bush that had held the settlers back. But it also seems fitting and poignant that nature has overwhelmed Nunhead Cemetery in the Borough of Southwark. Gravestones designed to endure are chipped and worn by the elements, enveloped in ivy and dislodged by self-sown saplings. The patina of time seems more fitting to the cycle of life than if the same environment had been held in stasis.

The Cross Bones graveyard is an entirely different setting and marks the site of a disused post-medieval burial ground in The Borough, just south of London Bridge. There is a space in the street where a building should be but the space is very quickly occupied when you discover why it is there. The graveyard currently belongs to Transport for London and much of it is used as a storage yard, but a decorated gate explains some of the history. It is believed to have originally been an unconsecrated graveyard for prostitutes, locally known as 'Winchester Geese' because they were licensed by the Bishop of Winchester to work within the Liberty of the Clink. The earliest mention of the graveyard is in John Stow's 1598 *Survey of London* when he describes it as the Single Woman's Churchyard. By the second half of the eighteenth century it was a pauper's cemetery. Up to 15,000 people are believed to have been buried here. There have been repeated attempts to develop the site but it seems unlikely that protestors will let the memory of these people go. The evolving memorial of ribbons, coupled with a 'gap in the teeth' created by the lot remaining empty and undeveloped are potent reminders of lives lived and keep this memorial alive.

MEMORIAL – NUNHEAD CEMETERY

The Memorial to the Murdered Jews of Europe (designed by architect Peter Eisenman and engineer Buro Happold) is an extraordinary thing to find just a short walk from the Brandenburg Gate in central Berlin. There are moments as you walk around it that the piece feels like a collective statement of guilt. It has only been able to happen here after enough time has elapsed for the Holocaust to fall into new focus. The power and formality of the piece makes it hard to imagine that it will ever be allowed to be softened as opinions change and memories adjust with time, it will be interesting to see if it is personalised in some way as the years go on by those with connections to the genocide.

Covering a whole city block, the site undulates gently over nearly five acres and 2,711 concrete slabs are ranked in a grid for repetition. Caught when the light is low in the morning the piece looks its lightest, but approach it from across the street and the blocks seem impossibly heavy. On entering, the corridors between them have a labyrinthine quality. You are compelled to move into the space and find yourself dipping down where the slabs extend above head height. Stand within it for even just a short time and figures that you see crossing the corridors take on a ghostly quality as they animate the passages. Though Eisenman is said not to have used any symbolism, the piece seems weighty with implication.

MEMORIAL – BERLIN

## LE PALAIS IDÉAL

Le Palais Idéal is a perfect example of a memorial in that it captures a life and the spirit of the man who made it. It is one man's obsessive vision and a world in itself fuelled by a fantasy.

Ferdinand Cheval (1836–1924) was a postman who spent thirty-three years of his life building Le Palais Idéal in Hauterives, northern France. The story has it that in 1879 he stumbled upon a stone on his post route and, inspired by its shape, returned to the same place the next day to start making a daily collection. He filled his pockets at first, a basket and then a wheelbarrow and took the stones back home where after his round he would build his palace.

The building has a powerful presence because each and every stone has been considered and placed by the maker. I loved it for the fact that you were so aware of the handmade quality, the idiosyncratic attention to detail and the fact that you can see the evolution of ideas unrolling like a story. The inspiration behind the architecture is biblical at points but at others you can clearly see the influence of Hindu mythology. This is a building that is considered down to the last detail, yet it is the lack of formality in the planning that gives it so much of its charm.

It is hard to say whether Cheval intended the building to be his mausoleum when he started to make it, but French law prevented him from being buried there. Though I did not see it when I visited, he is buried in a mausoleum it took him eight years to build in the cemetery of Hauterives. The building is regarded today as a fine example of naïve art, and towards the end of his life Cheval began to receive recognition from the likes of André Breton, Pablo Picasso and Anaïs Nin.

157

**NOTRE DAME DU HAUT**

I visited Notre Dame du Haut at Ronchamp on a day that was shrouded in mist. The chapel is a site of pilgrimage and you park at the base of the hill to make your way to the top on foot. This put me in mind of my Himalayan trip to the Valley of Flowers in Uttar Pradesh where the route we had taken was a pilgrimage trail for the religious. In many ways it was for me too as I was there to see the environment in all its glory and the passage and the time it took to ascend was as much part of the experience as the destination. The same was true for Le Corbusier's masterpiece. The chapel is carefully kept from view until you reach the brow of the hill and you are almost upon it, a device that so often increases the sense of expectation and the impact of the ultimate revelation. Though it was held in the mist, confined to its own space when I was there, the views on a clear day include the distant Jura mountains and an uninterrupted span of three hundred and sixty degrees.

Completed in 1954, Notre Dame du Haut is hardly typical of Le Corbusier and in place of his principles of standardisation is a specific response to the site. He is said to have sensed a sacred connection with the hill and responded to its past as a site of worship.

As a consequence, his machine aesthetic is absent here. It is a building that generates its own mood and the aesthetic and the principles behind it are cumulative. The organic forms are made rough from unfinished concrete. The angles of the walls set the building into the wind like a ship rising on a wave, the roof turned back, a billowing sail.

When it rains, the sloping roof gutters the water towards a natural fountain at the rear of the building. It is elemental. Weighty walls, more than six feet thick, allow you protection inside. They are perforated by abstracted slits that let in light, pure in places, and slashed with luminous colour from stained glass in others. A clerestory window separates the roof from the supporting walls and here the light that punctures the building is soft, allowing the rounded forms their moment. Detail is specific to the place. Vast, artisan door handles have a medieval quality, yet they are also completely of their time. There is an open-air altar and pulpit facing out into the prow of the hill that encourages the worshipper to look to the landscape for inspiration. This building celebrates the place as much as it does a god; the hill in turn, celebrates the building.

## JOSHUA TREE NATIONAL PARK

I have grown to like the feeling of space and the clarity that so often accompanies an arid landscape and over the years I have returned more than once to the Joshua Tree National Park, in the Mohave Desert. Though just a three-hour drive from Los Angeles, this reserve could not be more different, and with 29 Palms Inn as base, and an adobe building made from the same red earth that makes the landscape flare at sunset as your shelter, you are easily able to be part of it.

It was August the first time I visited and fiercely hot during the day, so we took to getting up at four in the morning before the first of the light had diluted the stars. We drove up into the National Park and were out of the car by the time the silveriness of dawn was changing things. Hugging the boulders and growing from nothing more than dust, were night-blooming datura. Their upward-facing trumpets were luminous and revealed themselves in the half-light. We had completely missed them during the day as they reduced back to the bare minimum to conserve their resources. Leaves, tight and clinging close to the branches, the bladder-like seedpods protected with barbs to keep them from being eaten, they were perfectly adapted to their surroundings. Native American Indians once used the plant for its powerful hallucinogenic qualities in a right of passage.

We picked our way through prickly scrub and jagged yucca and scrambled up the wind-blasted forms that repeated themselves into the distance. There was chill in the air and absolute still as we sat and watched the light intensify.

The silence of desert is a particular thing and you very quickly realise that for most of your conscious life you are filtering several layers of sound that, when stripped back, leave you with a very specific feeling. It is not emptiness that you are experiencing, as you are aware of everything. The first scuttle of a lizard as the sun breaks the horizon or the solitary screech of a bird's first calls or even your own breathing. You are thrown back on your senses, which allows you to get as close as you can be to your surroundings.

Long shadows replaced the blanket of grey once the sun broke free and I noted the importance of the forms that emerged from the gloom for the part they played in intercepting the light. The rocks held the light, halting it where it fell like topiary might in a garden and the vegetation was thrown into a frenzy of exaggerated textures as the leaf blades were caught low and sharp. This was a garden, where forms contrasted and complimented and colours yielded to their setting. Nature had struck a perfect balance between what the land and the climate could support. You feel that nothing is missing.

We watched the shadows retreat back to their origin as the sun lifted free of the horizon and the boulders once again sat back into the landscape, flattened by degrees as the sun climbed higher. Very soon the light was white, the heat getting prickly. It was time to retreat to earth, to the adobe.

162

JOSHUA TREE NATIONAL PARK

## HUNTINGTON BOTANICAL GARDENS

Huntington Botanical Gardens is a spectacular example of a garden that makes the most of its natural resources by taking advantage of the low rainfall and the year-round sunshine. It is situated on the outskirts of Los Angeles, a city that in the most part turns its back on the natural state of things where gardens are concerned. Not far away at the Joshua Tree National Park, a natural garden can be found thriving in these conditions, but in the city water switches over vividly green lawns and sidewalks. If the irrigation systems that squander this precious resource were to fail, the folly would be exposed in a matter of days.

Though Huntington is a place of great breadth – there is even a Japanese garden there as a crowd pleaser – the most successful areas are those that use the climate to its full potential instead of working against it. The Desert Garden is an extraordinary thing in terms of form and texture and, to my Englishman's eye, it is like a cartoon garden where all the shapes are heightened, drawn large or exaggerated. Barrel cactus appear to have been rolled out like a game across hot gravel, aloes look as if they have been moulded from rubber, pulled from the ground like elastic. The plants here are adapted to the light, which in such intensity amplifies their outlines. Their shapes and forms are evolved to harness the dew, which travels in cool nights down carefully designed ridges towards the root. They are white or shiny or covered in hairs to refract the light, and leaves are reduced to wire-thin stems or in some cases, fleshy storage organs that barely resemble foliage. The plants are otherworldly, a sculpture garden using plants as the raw materials.

166

HUNTINGTON BOTANICAL GARDENS

## LOTUSLAND

Gardens are often places in which people indulge their fantasy or their dreams, or play out the lives they may not be able to live in the real world, but can in a setting of their own making. Lotusland in Montecito, California is one such example. The gardens were created between 1941 and 1984 by Madame Ganna Walska, an opera singer who owned the property and sank a considerable amount of her inheritance (she outlived several wealthy husbands) into their creation.

I visited one balmy afternoon in November and was allowed to roam free in the grounds. These are extensive and, like a Russian doll, there is a series of gardens within a garden. In total, it is clear to see that they are the product of a woman with a vivid imagination, considerable appetites and a vision that was very much her own.

The gardens wrap around a low-slung building that lies in the centre of the grounds and they make no concession to gardening with nature, for Walska was interested in a larger-than-life aesthetic that was operatic in its way and certainly not lacking in drama. The entrance to the house has a hacienda quality about it with dramatically contrasting cacti and coloured walls, but the lawns to the other side at first seem calm and tranquil, until you notice that the twisted oak in the centre is hung with baskets of insectivorous plants, orchids and bromeliads. They sway gently in the breeze, casting exaggerated shadows onto the lawns. A lemon walk focuses a formal avenue of tightly trained trees into a covered walkway and your passage to the vegetable garden is heavily perfumed.

The blue garden lies in the slanting shadows to the other side of the garden and the evening is the perfect time to see it as the colour is luminous and hovering late in the day. Jagged blue agave, each the size of a room, twist and coil. Blue fescue grass form a vivid carpet and glaucous atlas cedars and Mexican blue palm lift the eye. A swimming pool surrounded by white conch shells is not far from here. There are lotus in the shadows and delving deeper into the undergrowth of papyrus, bamboos and fern you come upon an eerie collection of more than four hundred cycads thriving here, unchanged by the millennia of evolution.

There is a little theatre that is particularly memorable, which uses hedges for the wings and grass terraces for the stage and the seating area. It is peopled by a collection of quirkily animated stone figures that were buried for safety in a midden in the grounds of her Italian house during the war. They give a voice to this fantasy place, which stays with you long after you have left it and are back on the road to Big Sur.

172

## KIRSTENBOSCH NATIONAL BOTANICAL GARDEN

Kirstenbosch National Botanical Garden, in the Cape of South Africa, was founded in 1913 to preserve the country's unique flora. It was the first botanical garden in the world with this ethos and in my mind it is the most extraordinary place, for not only does it engage completely with its setting on the slopes of Table Mountain but it seamlessly blends a manicured garden with the natural landscape. The collection is brilliantly displayed and the rhythm of the plantings changes as you move toward the wilder outskirts of the garden. Close to the buildings, the gardens are more conventional with lawns and water, and ubiquitous agapanthus are juxtaposed with the more sculptural natives. Many of the plants are plants that you recognise but are surprised to find running wild until you remember this is their homeland. Everything sparkles, warm air shifting foliage, the smell of foreign vegetation curious and musty-sweet.

As you move up the hill, the collection becomes increasingly naturalistic. You pass through thickets of protea that have a prehistoric mood about them; ancient and intrinsically exotic. You can see tribal costume in the tufts and patterning of the flowers. Humming birds flit and glitter, emerald-green, turquoise and rust-red. The garden is remarkable too for the panoramic views of the landscape all around it, the sea shimmering below, and the mountain reaching up above marking a powerful horizon line. The clouds here are bigger, the air somehow more plentiful and this seems reflected in the way that everything grows.

There are no boundaries on the upper reaches of the garden and you pass through silver-leaf banksias up a ravine called Skeleton Gorge. This is an easy and popular route to the summit of Table Mountain and you realise somewhere along the trail, and without being told, that you have crossed an invisible border between garden and nature.

174

KIRSTENBOSCH NATIONAL BOTANICAL GARDEN 175

## CABO DE GATA

The Cabo de Gata in Andalucia is one of the driest parts of Europe and across the water, separated by just a short distance lies the coast of Morocco and the influence of Africa. You can feel it in the pale, dusty hills and in the light, which is dazzling at the height of the day. We make a pilgrimage there most years. At first, touching down after an early morning start, the drive up the coast from the airport reveals what initially appears to be not much more than scrub and wasteland but over the days, once you retrain your eye, the essence of the landscape becomes apparent.

It takes a while to get your eye in but over the course of the time we are there, a simple routine is set in place that revolves around a daily walk over the headland to the isolated beach in one of the coves below. The walk becomes a meditation and with each day that you tread the trail, you get to know the landscape with an increasing intimacy. You come to recognise the stones on the path, the easiest way to move from one to the next, and the very point at which the murmur of the waves leaves you as you swing inland and down into the valley.

The silence that is particular to these landscapes is present as soon as the wind dips and with each day that passes you adapt to this certain way of seeing, the way it feels to be here.

The daily passage reveals the layers so that the apparent starkness and the dust of the first day are replaced by the same landscape in a range of browns the next. And so it goes on as your eyes begin to recognise and then to seek out the detail. The patina is revealed with increasing clarity: the lichens on the rocks in acid green, rust and black that have taken so long to form where the stones lie undisturbed; the range of delicate textures in the scrub, hard, wind-formed and reduced; the orange pollen sacks on the grasses that at first seemed so dry and so uniform. These are the things that make this landscape particular.

I often wonder whether it is the silence and the space that comes with it, that allows you to tune in to the detail, but the heightened awareness is triggered as much by the repetition of routine; the meditation. It allows you to build a

CABO DE GATA

consciousness that is cumulative and informed by what has come before, each layer, like the lichens, adding to the depth of colour and the dynamism of the place. Perhaps the struggle to see the beauty when first confronted with something new and alien is as much to do with recognising it as it is to do with finding a way to seek it out.

This is what the days here are about and each of the senses is teased out of hiding as you come to be in the moment. A blinding, white-hot day will allow you to concentrate on the sound and weight of your footfall, the hiss of the wind in the tussocky grasses, the still as you descend into the hollows and the smell of rosemary and thyme. Evening light will reveal the landscape differently so that another range of senses come into play when your eyes are no longer struggling.

As you swing down to the beach, the cliffs that have been eroded into Gaudiesque forms catch the light in their folds. The stone is black or white when the light is bright, grey and faun when the sun dips. The platforms of rock spill out into the sea where they have been time-worn into folds and undulations and where the sea has dragged their surface there are rock pools. They drag, gulp and gutter on a stormy day as the water moves through them. They are bathing pools when the sea is quiet, still and rounded, mirror flat and reflective. A place to contemplate how the world is revealed when you give yourself the chance to take things slowly.

CABO DE GATA

CABO DE GATA

## ALHAMBRA

Walking through the town along the River Darro, you see the palace of the Alhambra sitting on top of the hilly terrace above you. The streets are intricately cobbled, the stones worked smooth with time and it is a slow walk uphill through the heat. You hug the walls that cast the shadows.

The woods that surround the Alhambra are in sharp contrast to the arid lands of Andalusia and gave rise to the poetic Moorish description of the once white-washed palace as 'a pearl set in emeralds'. Once inside, you soon understand that the palace was designed to reflect the beauty of paradise. The landscape beyond is all but shut out.

The repeat of open and closed rooms set up a rhythm as you move through the palace and you are never far from being outside when you are in, or in when you are out. The majority of the palace buildings are, in ground plan, quadrangular, with all the rooms opening on to a central court. In places, there is a powerful simplicity, a Moorish arch in honey-coloured brick, a set of geometric steps descending; but there is also considerable opulence. Intricate carving in stonework repeat and expand upon repeat. A ceiling becomes the roof of a cave, a honeycomb of formalised stalactites. Natural light is used to graze the carving, to highlight the texture and to play with colour. Where colour does appear it feels staggeringly modern and it makes perfect sense that M.C. Escher's study of the tessellations in the Alhambra tiles following his visit in 1922, inspired his own experiments in the regular divisions of planes.

Shade is all important and there is a play of light and dark throughout as you move from room to room. From the safety of the shadows the bright light outside plays with the fretwork of carved screens. It also pierces the building where the open courtyards have the sky as their ceiling. There is always somewhere in the shade, a cloistered route around a courtyard or tall hedges, and where the sun does fall to ground there is invariably water to bounce light and capture it.

Water is key to the experience and great efforts were made to channel it to the palace through a five-mile conduit connected with the Darro at the monastery of Jesus del Valle above Granada. In a climate where water has a very real value, its presence is luxurious and it follows you through the palace and the gardens to guide your way. It descends with you from step to step in a rill that whispers then stills in the path and you are encouraged towards it repeatedly.

Water also helped to cool the palace and in the Patio de la Alberca, the *birka* (the Arabic for pool), dominates the space as a symbol of power. Technically it was difficult, complicated and expensive to keep these vessels permanently full, creating the potent and mystical illusion that they never evaporated. The large pond in this courtyard is set in the marble pavement. It is inky green and reflective of the sky and the buildings. Where the coloured tiles on the wall have their own very formal movement, the flashes of goldfish in the water are there to break the reflection.

187

Water provides punctuation. A tiny fountain in a solitary basin is the only furnishing to one empty courtyard. You pause to listen to the echo. You feel refreshed. A series of fountains choreograph other areas, giving each its own identity. They jump from land to water in a star-shaped pool, or form a repeat of light-filled cords that line the canal in the gardens of the Gineralife or Garden of the Architect.

You leave the palace through a leafy nut grove of contrasting informality, descending the hill down into the town in a series of steps and landings. As a last hedonistic treat a rill accompanies you in the handrail that takes you back into the heat of the real world.

ALHAMBRA

189

## WATER

Water is a vital element. It is the lifeblood. Without it, a garden is reduced to form and architecture and it has an unspoken value as stimulus to the senses. You can smell water, feel it in the air before you see it. You want to touch it and having it near is fundamental. It soothes or energises depending whether it is static or in flux and subliminally the sound of water is a focus that can be depended upon to mollify and to calm.

As a raw material, water is a focus. It offers reflection (both physically and metaphorically), bringing the sky to the earth and repeating imagery. It can stretch space in a large expanse and the great garden makers of the past perfected the art of using it to alter and heighten mood and space. Moorish gardens separated desert from oasis by its inclusion. The smell of water in a dry climate, its cooling value and the life it sustains were a metaphor for power, wealth and prosperity. In Japan, it is a bowl that greets you at a gateway so that you can clean your hands before entering. Often two thirds of a Japanese garden is given over to the glassiness of water, the stroll around it never moving far from the mirror it provides the visitor. In Britain the great landscapers of the eighteenth century also depended upon it, never letting you see it all at once so that your mind continued the illusion far beyond the confines of the space provided. Villages were moved to include it in the landscape and years were put aside for valleys to be dug and flooded.

As in the past water today is often a means of animating space and may be used with architecture, as a component of memorial or play. A city waterfall, such as the Shodo Suzuki waterfall I came upon in the centre of Tokyo, can draw people from all walks of life to meditation. It is elemental. Bigger than the space it occupies. The geysers in Parc André-Citroën in Paris or Somerset House in London are pure play and adults and children alike will partake in the energy they provide. I made it a mission to find the bronze fountains by George Tsutakawa (1910–1997) when I was in Seattle. His work was playful and used the material masterfully, the bronze forms at one point fusing with the liquid catalyst, at others causing reaction and energy. The fountains transformed a plaza, making the flyover, the road and the city hubbub retreat and actively allowing you to feel lighter and energised.

In my own garden, I have two vessels of water. The first, by the house, is placed under the cercis. It captures the reflection of twigs and sky in the winter and it is the means by which I can tell if it is raining or if there is a freeze of any significance. Birds and cats use it in alternation. A copper repeats the focal point further into the garden. A single water lily provides the seasonality here, retreating to mud in the winter and coming to surface in the growing season.

191

WATER

## VILLA D'ESTE

Photographs flatten the experience of being in a garden and though it is impossible to convey the sensuality and the complete immersion, film is a medium that comes close to conveying the mood. I first saw the gardens of Villa d'Este in the *Eaux d'artifice* by Kenneth Anger. Anger's film is a simple idea, but one that conveys something of the decadence of a garden driven and choreographed by water. An eighteenth-century figure descends through a series of terraces, fountains and waterfalls. Set at night, there is a blue cast to the footage and moonlight is caught in the waterworks. For sure, the fantasy of this place is there in the film, but the magnitude and all-encompassing sensuality of actually being there is missing.

At almost five hundred years old, the Villa d'Este still represents an extraordinary feat of engineering. A whole hillside was remodelled between the years of just 1563 and 1565 with an aqueduct built to capture the waters from Monte Sant'Angelo to feed the planned waterworks. When that did not prove to be powerful enough to drive the fountains, a subterranean canal was constructed under the town to harness the waters of the Aniene River as backup. At the time of its construction the villa was described as a new landscape or what was referred to as 'a third nature'. I love that description and though it is open to interpretation, the garden is a wonderful mix of solid and shaped architecture. The stonework provides the bones and the physical means to move through the space, the water, the light-filled extension to it with its constantly shifting energy.

The gardens occupy a stretch of hillside below the town of Tivoli with spectacular views over the hot plain towards Rome. You enter the dim rooms of the villa before being presented with the hillside over which the garden pans out beneath. The juxtaposition of heat and the refreshing, revitalising nature of the water are absolutely key to the experience and very soon, as you move into the first of the terraces, you can feel yourself intoxicated by the vitality of the place. There is moisture in the air, the sound of water at every turn and light caught and played with. Everything within range of the moisture is coated in liverworts, and encrusted with moss, and the patina softens the formality of forms long overwhelmed and morphed by the encrusted greenery.

The passage through the garden descends from terrace to terrace via a series of steps. Water is your constant companion and it trickles, dances, roars and even sings in the Fountain of the Owl – though there is play enough not to worry about detecting the birdsong. Rarely, at least until you reach the end of your journey, does the water still or appear unbroken and glassy.

The journey is entirely sensual and the acoustics of each of the areas and the dynamism with which the water is manipulated is constantly mood altering. In the procession of the Hundred Fountains, there is a repeat pattern formed in two levels of fountains. Though the fountainheads were once configured as a set so that the water played like a series of identical notes, now they are misshapen by moss so each of the sprays of water is different. There is a rustic cascade at the end of this walk with a lilting boat that is decidedly kitsch, its rigging formed by water shoots, and there are numerous amusements tucked away to support the main attractions. A many-breasted Diana forms a focal point in a quiet corner on the lower terraces, there are beasts spitting water, shells overflowing with it and fountains forming a latticework against the sky with rainbows caught in the spray. There is playfulness and theatricality throughout the experience and I could not help but see it as the seventeenth-century equivalent of a theme park.

At the opposing end of the terrace of the Hundred Fountains, is a vast curtain of water that drops into a pond broken by a white arc where the two collide. There are jets projected into the pond to disturb the surface further should the spill of the curtain not be enough. Not far from here you are invited into two caverns where water is collected at great speed to feed the geysers on the next level below. People enter these tight enclosures and often leave at a pace with the whites of their eyes showing because the commotion and the volume inside is so exhilarating. You can stand on the terrace beside the caverns and look out over the garden and almost touch the tops of the geysers that are pulsing up alongside you from below. These must be well over sixty feet high and are as light-filled and energised as the columnar cypresses around them are dark and still. You find yourself wanting more of the rush but wonder how it might be possible.

Finally, and only once you have been satiated, you reach a milky pool on the lower levels. It is glassy and reflective and not far from a balustrade over which you can lean looking towards the heat of the plain and Rome.

## FONTANA DI TREVI

It is amusing to think that there is a scaled down version of the Fontana di Trevi at Caesar's Palace in Las Vegas and when you first come upon the original in Rome, there is something undeniably kitsch about its opulence. I am not usually attracted to ornamentation but it is difficult not to be drawn to the energy of this fountain. At night the mood is more potent than it is during the day and the sound of the crowds that are attracted to it is drowned out by the rush of water. It is interesting that the roar of the water cuts to silence as Anita Ekberg wades through it in Fellini's *La Dolce Vita*. There is a hypnotic quality in the water's commotion that is part of the power of this piece. The lighting is golden at night and reflections are bounced from the cascades onto the surrounding buildings and the faces of the people gathered to the spot.

Though the magic of night-time is altered by daylight, the fountain is equally as fascinating once you study its juxtaposition with the buildings. It grows anthropomorphically from the Palazzo Poli, which forms its backdrop, the stone left rough and unfinished where the building grows from it. There is also tension between the richly baroque statuary and the organic forms into which it is integrated. A cut stone bench grows from the rough fissured stone. A drinking trough sits to the side of the formal fountain with deliberately worn paviers and seat, two arcs of water delicately allowing the visitor to quench their thirst. Succulents, figs and seedling oak trees are carved into crevices as if nature and art could not help but be cheek by jowl. People have also made their mark in tiny scribbled love messages and the stones are rounded and polished by feet and bottoms. It is a clearing amongst the tight streets of Rome that is magnetic, where, despite the crowds, you can be in your own space, without distraction.

200

FONTANA DI TREVI

## TORRECCHIA

Torrecchia is an estate of some five hundred hectares. It lies on the edge of the agricultural plains forty miles south of Rome. In 1994 the late Violante Visconte and her partner Carlo Caracciolo approached me to help them make a garden there. They had acquired the estate not long beforehand and, from decades of vegetation, had unearthed a medieval hill village that lay in the centre of a volcanic plug. Within the walls they intended to make a garden that felt as if it were on the brink of being overwhelmed by nature, and the derelict village and the surrounding woods were the key to what would be right and fitting there.

There are troglodyte caves in the hills approaching the village and above them the ancient cork oaks, their trunks glowing red in the years that they are harvested. In the heat of the summer, a skirt of black shade makes them hover on the dusty hillside and long-horned cattle gather there for shelter. In the little valley below, a Roman bridge greets you as you break out of the dense forest that surrounds the plug. It was once part of the old Roman way that ran from Rome to Naples and the track still follows the stream in the nut woods there. These woods, primitive and rough, are pink with *Cyclamen hederifolium* in the autumn and, blue with *Anemone appenina* in the spring.

The ruin itself is surrounded in mystery, it had been deserted eight hundred years previously, possibly because of malaria or an earthquake that seemed to show itself in rents through some of the buildings. Violante and Carlo had already made a start with Lauro Marchetti, the curator of the gardens of Ninfa, and the village had been cleared to reveal the walls and the topography, the infrastructure to resolve the irrigation taped into an underground aquifer. In doing so they had found indications of a Roman settlement that predated the medieval village. A limb from a statue and beautiful terracotta drain tiles had haphazardly come to the surface so they decided to tread lightly to avoid unnecessary disturbance. After the walls were carefully cleared of ivy and bramble they were painstakingly stabilised to prevent further decay. Gae Aulenti (architect of the Musée d'Orsay in Paris) had been appointed to make a series of apartments within the ruins of the derelict castle and a home in the eighteenth-century granary.

Violante explained that she was after an Englishman's eye. She wanted a garden that was nothing to do with the order normally associated with the Italian style of keeping nature at bay. She wanted a garden that looked as if it were growing out of the ruin of Torrecchia and for that, it had to have a very particular atmosphere. She was resolute about the way that she wanted the garden to feel. 'Daniel! This is southern Italy, I want everything to be green. There will be no silver, no colour other than green and white. I want cool colours.' She had made a start already. Passion flowers and wisterias had been sent up the trees and the walls of the ruins, scaling thirty, forty feet in a season. Once I had her confidence, we started to work together to make a garden that, at one moment, was all about restraint and nothing more than the shifting shadows on lawn and the next, a fecund, rustic romance. There was roughness around the edges and the boundaries were always blurred.

The paintings of Claude or Poussin felt completely appropriate to the mood that was to be captured and heightened in the greater part of the garden, but there were areas where things could afford to feel a little surreal. The light was essential in this and she wanted the swimming pool, which was sunk into the collapsed basement of the castle, to look like a scene in a de Chirico painting. The ruin's windows opened onto nothing but blue sky and the planting was kept to an absolute minimum. Dark bay and scented jasmine. The terraces, close to the house were essential for shade and these were to be sensual and opulent with white wisteria and hydrangea close to the living areas and perfumed wherever possible, but as you moved from the building they were to become progressively more rustic with wild rambling roses over simple wooden bowers. The view out over the valley was key within the garden and breaks in the walls where the windows had been would be the focal points to take your eye out over forest. Looking in, a series of meandering paths lead you from place to place in a natural, unplanned manner. You came upon steps to lead you from level to level and mood to mood and carefully chosen positions for sculpture. You would always come upon this as a surprise.

Trees have been kept multi-stemmed in the garden so that they feel wild, and minimising the use of colour has kept the garden feeling pure. You can feel the bones and the history because distraction is kept to a minimum. White banksian roses, smelling of violets at Easter, are allowed to festoon the castle walls, clambering sixty feet to cascade back down again, untamed. Wisteria and *Rosa* 'Mme Alfred Carriere' take other buildings. Inky bay is used to make the connection to the evergreen oaks beyond the walls and to create dark pools for the bright light to be absorbed into. Magnolias and handkerchief trees throw pools of light into the garden as

TORRECCHIA

contrast. A young English gardener, Stuart Barfoot, who we appointed a decade ago has been keeping the aesthetic true to this vision, as the garden is fugitive and always in flux.

The plants are massed so that the pacing revolves around a series of events. A ravine of scented crab apples, incandescent with blossom in April, the floor a carpet of violets and hung with fruit in the autumn. The garden erupts and shape-shifts between seasons. Blues are allowed to hover in shade like the anemone in the woods, flowers are kept simple and single and as close to type as is possible. The purity is crucial as a counterpoint to the slightly melancholy mood. These interludes in the seasonality of the garden are intended to be sensual and all consuming and you are encouraged to be lost there for the time they hold your attention. The combinations of light and flower or scent or moisture in the air are something that can never be repeated, for each is specific to the way that the components come together at that particular point. It is the garden that puts you in the moment and you savour the brevity in the knowledge that it will never be repeated in quite the same way again.

Those gardens that use nature for their romantic gain, but strike that delicate balance between it being invited in and not quite having the upper hand are always in the balance. The most romantic moments at Painshill are those on the edge of being lost, the entwined stones in Nunhead Cemetery are the places with the most resonance. It is in this balance that I find the most evocative moments, the points where the magic occurs. I suspect that the ephemeral nature of these interludes is the greater part of their appeal, and for me, trying to capture them is part of the art of garden making.

**ACKNOWLEDGEMENTS**

Thank you to Stephen, Damon and Anna at Fuel. It is very good to be part of your well-crafted stable of books and I have enjoyed the process and your good eye. Thanks also to Beth Chatto and Paul Smith for your kind words and enthusiasm.

Thank you Huw, for your shared vision and for your thoughtful and continual support in the making of this book. It would not have been possible without you. I would also like to thank Huw for his pictures and Andrew Lawson for images of the roof garden in Bonnington Square, Wolfgang Koellisch for those of the Memorial to the Murdered Jews of Europe and Donald McIntyre for the details of woodcraft in the Cherry Wood Project.